Digital Photography

PEARSON

Harlow, England • London • New York • Hong Kong
Tokyo • Seoul • Taipei • New Delhi • C • Paris • Milan

PEARSON EDUCATION LIMITED

Edinburgh Gate
Harlow CM20 2JE
Tel: +44 (0)1279 623623
Fax: +44 (0)1279 431059
Website: www.pearson.com/uk

First published in 2011
Second edition published in Great Britain in 2012

ISBN: 978-0-273-77478-5

British Library Cataloguing-in-Publication Data
A catalogue record for this book is available from the British Library

Library of Congress Cataloging-in-Publication Data
Campbell, Marc.
 Digital photography in simple steps / Marc Campbell. -- 2nd ed.
 p. cm.
 ISBN 978-0-273-77478-5 (pbk.)
 1. Photography--Digital techniques--Amateurs' manuals. I. Title.
 TR267.C333 2012
 770--dc23
 2012016686

10 9 8 7 6 5 4 3 2 1
16 15 14 13 12

Typeset in 11/14pt ITC Stone Sans Std by 3
Printed in Great Britain by Scotprint, Haddington.

Digital Photography

n **Simple**
steps

Second edition
Marc Campbell

Use your digital camera with confidence

Get to grips with digital photography tasks with minimal time, fuss and bother.

In Simple Steps guides guarantee immediate results. They tell you everything you need to know on a specific technology subject; from the most essential tasks to master, to every activity you'll want to accomplish, through to solving the most common problems you'll encounter.

Helpful features

To build your confidence and help you get the most out of your digital camera, practical hints, tips and shortcuts feature on every page:

 ALERT: Explains and provides practical solutions to the most commonly encountered problems

 HOT TIP: Time and effort saving shortcuts

 SEE ALSO: Points you to other related tasks and information

 DID YOU KNOW? Additional features to explore

WHAT DOES THIS MEAN?
Jargon and technical terms explained in plain English

Practical. Simple. Fast.

Dedication

Despite what it says on the cover, writing books is a team sport. And when your team includes Neil Salkind, Andrew Kim, Joli Ballew, Steve Temblett, Robert Cottee, Melanie Carter and Vivienne Church, your book is in very good hands indeed. In my last Simple Steps book, I was a little stinting in my gratitude and praise for the work of the marketing team; I'm happy to say that, as of this book, your marketing lot are alright with me.

Author's acknowledgements

I'd like to dedicate this book to the little mouse who kept me company through the long and otherwise lonely hours that a nocturnal author by necessity keeps. Sorry for all the traps.

Publisher's acknowledgements

The publishers are grateful to the following for permission to reproduce copyright material:

Photos: Pp. 3, 8, 9, 10, 18, 21, 22, 29 (left), 32, 35, 42, 48, 60, 67 (bottom left and right), 68, 87 (top and bottom), 90, 91, 92, 105, 107, 108, 111, 112, 113, 117, 118, 119 (top and bottom), 122, 142, 143, 148, 149, 153, 154, 155, 178 © Pearson Education Ltd; pp. 24, 25, 55 (top), 181 © Getty Images; p. 26 © Blend; pp.29 (right), 30 (left), 61 (top), 85, 95, 96, 104, 106, 141 © Studio 8; pp.30 (right), 39, 50 © Digital Vision Ltd.; pp. 4 (right), 31, 37, 38 (top), 57 (right), 58, 60 (bottom), 61 (bottom), 93, 94, 110, 120 (top), 121, 146, 147 © PhotoDisc; pp.33, 37, 40 (top, middle and bottom), 49, 64, 65, 183 © Imagemore Co Ltd.; pp.34, 56, 58, 67 (top), 103, 109, 150, 156, 164, 165, 166, 169 (top), 170, 171, 172 (all top), 185 (both) © www.imagesource.com; pp.36, 46, 47 (both), 51 (left), 114, 115, 152, 184 © Imagestate Media; pp. 4 (left), 38 (left) © Bahamas Tourist Office; pp.41, 66 © Eyewire; pp. 5, 45 © Creatas; pp. 48 (bottom), 57 (left) © Corbis; pp.51 (right), 62 © Datacraft Co Ltd; p.52 © New Holland; p.55 (bottom) © MIXA Co Ltd; p.63 (both) © BananaStock; pp.116, 151 © MindStudio; p. 120 (bottom) © Comstock images; pp. 144, 145 © Alamy Images.

All other photos © Marc Campbell.

Screenshots: All Picasa and Google+ screenshots appear courtesy of Google Inc. In some instances we have been unable to trace the owners of copyright material, and we would appreciate any information that would enable us to do so.

Contents at a glance

Top 10 Digital Photography Problems Solved

Contents

9 Edit the image in Google+

10 Make prints (and more)

Top 10 Digital Photography Problems Solved

Top 10 Digital Photography Tips

Tip 1: Download and install Picasa

Picasa is free software from Google for organising and editing digital photos on your computer. While you may have received similar software on the CD-ROM that came with your camera, Picasa is often better at the tasks of organising, editing and sharing.

1 Go to http://picasa.google.com/

2 Click the Download Picasa button.

3 Install the software as applicable.

Tip 2: Set the picture quality

Picture quality in digital photography refers to the amount of digital information that the photo contains. The greater the information in the photo, the better it tends to look but the more space it takes up on the memory card. It's up to you to decide whether you want to shoot more lower-quality photos or fewer higher-quality ones.

1 Using your camera's menus, find the setting that controls picture quality.

2 Choose Good or Standard quality for images that you do not plan to print; these images often contain visible *artifacts* or defects when you look closely.

3 Choose Better or High quality for images that you plan to print as snapshots.

4 Choose Best or Super-high quality for images that you plan to print at larger-than-snapshot size.

HOT TIP: Changing the picture quality does not affect the quality of the photos that you have already taken.

HOT TIP: It's better to take photos at the lowest quality setting and risk getting some artifacts than to miss once-in-a-lifetime photo opportunities.

Tip 3: Use Scene modes

Your digital camera's Scene or SCN modes provide a quick way to adjust a variety of camera settings, including focus, exposure and white balance, according to common locations (Beach), subjects (Fireworks) or shooting conditions (Night). Scene modes often give you better photos than your camera's general settings for the types of situations that these modes describe.

1 Find the Scene or SCN controls on your camera.

2 Choose the mode that best describes your current shooting conditions or the subject of your photo.

3 After taking the shot, return the camera to its normal setting.

HOT TIP: Your camera may provide more SCN modes in its menus than appear on the dial control.

ALERT: Do not infer from your Underwater SCN mode that your camera can take pictures underwater. Just because your subject is underwater does not mean that your camera can be there, too.

Tip 4: Use the zoom

The Zoom control on your digital camera makes faraway subjects appear closer. Many digital cameras offer two kinds of zoom: optical and digital. Optical zoom helps to reveal fine detail and it doesn't degrade image quality at all, although it does tend to flatten perspective. By comparison, digital zoom is a form of image processing that does not reveal any new detail in the image; in fact, it can introduce a noticeable loss of clarity, even at moderate levels.

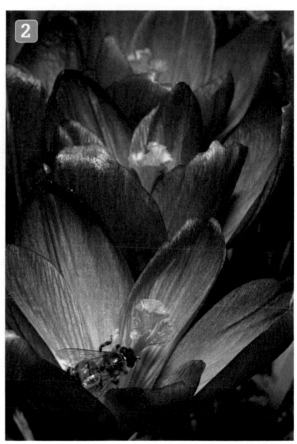

1 Find the Zoom control on your camera. It may be one of the rings around the lens, or it may be a lever or a set of buttons.

2 Experiment with this control to see how it affects the amount of zoom in the shot.

3 If your camera offers both optical and digital zoom, and if your camera engages digital zoom automatically, find the digital zoom setting in your camera's menus:

 a Turn digital zoom on if you don't mind some loss of image quality when you exceed your camera's optical zoom rating.

 b Turn digital zoom off if you don't want to risk loss of image quality at the expense of some extra magnification.

 DID YOU KNOW?
The best substitute for zoom is simply walking closer to your subject. It achieves the same result as optical zoom.

 HOT TIP: Apply your own digital zoom in image-editing software by blowing up the image and then cropping it.

Tip 5: Connect your camera to your computer

Now that you have set up your computer for storing your photos, you can connect your camera to your computer. Before you start, take out the interface cable that came with your camera. In most cases, this is a USB cable, or it may be a FireWire cable; for the connection to work, you must have the same sort of connector port on your computer. In the event of a mismatch, you may be able to buy a converter plug, or you might think about getting a separate memory card reader.

1 Turn off your camera.

2 Plug one end of the interface cable into the output port on your camera.

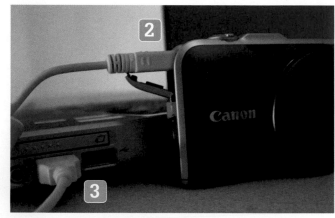

3 Plug the other end of the interface cable into the corresponding port on your computer.

4 Turn on your camera.

5 If necessary, set your camera to Transfer mode; refer to your camera's manual for details.

6 Import photos according to the instructions later in this chapter.

7 When you have finished, set your camera to Capture mode (if applicable), turn it off and unplug it.

ALERT: Always turn your camera off before you unplug it.

? DID YOU KNOW?

Some cameras enable you to connect to your computer wirelessly. If yours does, you don't need to run a cable between the camera and the computer.

HOT TIP: If your computer has a memory card reader, you can transfer your photos directly from the memory card. Simply eject the memory card from your camera and insert it into the card reader.

Tip 6: Make backups of your imported photos

Backing up your photo files is the single most important task that you'll read about in this entire book. It might feel like a bother – and I won't say it isn't – but compare a few minutes of tedium now against the crushing disappointment that you would feel if you lost your priceless, irreplaceable memories to something as trivial as a technical glitch. As soon as you transfer a batch of photos to your computer, every time, without exception, create a set of backup files.

1 In Picasa, choose Tools > Back Up Pictures.

2 Choose your Regular Backup set from the Backup Set drop-down menu.

3 In the list of folders on the left, tick all the folders that you wish to include in the backup.

4 Click Backup.

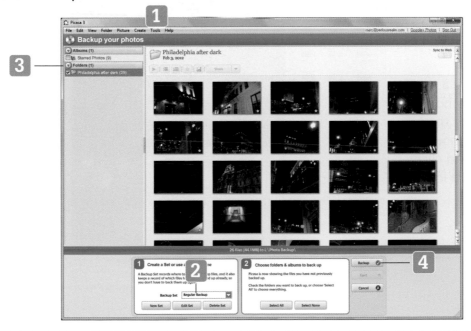

HOT TIP: Picasa keeps track of which folders you have backed up, so you won't need to back up the same folders more than once.

Tip 7: Tag a photo

Tags are words or short phrases that describe the subject of the photo, the location, the situation, the people in the background and so on. Like the caption, tags are part of the photo's metadata, so they follow the photo wherever it goes. Tags are most useful for searching. A photo's file name is usually not descriptive, and the folder in which you store the photo is too easy to change. Moreover, your computer is not yet sophisticated enough to scan the image itself and understand what or who it's looking at, at least not as reliably as you can. So by adding tags to the metadata, you're essentially providing a search-function cheat sheet. When the search is for *Mary* or *Piccadilly Circus*, for example, photos with these particular tags appear in the results.

1 In Picasa's Library view, double-click the photo that you want to tag.

2 Click the Show/Hide Tags Panel button.

3 Type tags to add to the photo, pressing Enter or Return after each one.

4 To remove a tag from the photo, hover over the tag with the mouse pointer and click its Remove icon.

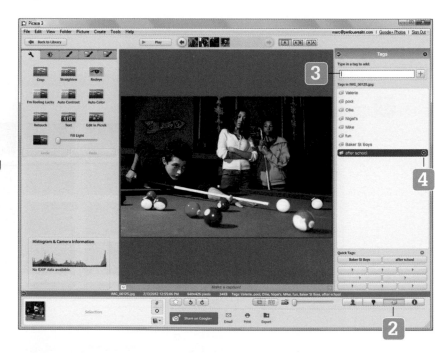
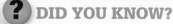

Tip 8: Crop the image

Cropping your photo means to trim its edges to get it to fit a certain set of dimensions. This technique is crucial for sizing your photos before you make prints. If you supply uncropped photos, many print services will simply crop them for you with the level of care that you would expect from a faceless, cost-obsessed corporation. Save yourself the frustration of poorly cropped prints by making your own cropping decisions.

1 From the Commonly Needed Fixes tab in Picasa's Edit view, click the Crop button.

2 Choose the desired dimensions or aspect ratio from the drop-down menu.

3 Move the mouse pointer onto your photo and drag the mouse to create a crop area of your chosen aspect ratio.

4 Release the mouse button.

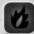 **HOT TIP:** For any given aspect ratio, Picasa automatically suggests three crop areas, which appear as the three thumbnail images directly below the drop-down menu. To apply one of these crop areas, click its thumbnail.

HOT TIP: Change the aspect ratio of the crop area by choosing a different option from the drop-down menu.

5 Position the crop area by dragging it, or drag the corners of the crop area to resize it.

6 To rotate the crop area, click Rotate.

7 To preview the cropped photo, click Preview. Picasa automatically reverts to the original photo after a second or two.

8 To start again, click Reset.

9 Click Apply.

Tip 9: Upload photos to Google+

If you sign up for Google+, you can upload your photos to the social network directly from Picasa. The software keeps track of which photos you've uploaded from which albums and folders.

1 In Picasa's Library view, click a photo to upload to Google+. If you want to include all the photos in an album or folder, simply click the album or folder.

2 Click the Hold Selected Items button in the tray at the bottom left of the window.

3 Click the Share on Google+ button. If you aren't already signed in, Picasa asks for your login information.

4 Do one of the following:

 a Use the new Google+ album that Picasa automatically creates.

 b Choose an existing Google+ album from the drop-down menu.

 c Click New, then type a name for the new Google+ album.

5 From the Image size to upload drop-down menu, choose the appropriate size for the online versions of your photos.

6 In the Add a message field, type an optional message to go with these photos.

7 Click the field beneath the Add a message field to determine which of your Google+ contacts can see these photos.

8 Click the green Share button (if you have selected contacts) or the green Upload button (if you have not).

9 Click Upload in the dialogue box that appears, if necessary.

 HOT TIP: You can also upload photos from your Web browser when you're logged into Google+. Browse to your Photos page and click the Upload New Photos button, or open any Google+ album and click the Add More Photos button.

 HOT TIP: To select multiple photos, hold down CTRL (Windows) or CMD (Mac) as you click with the mouse.

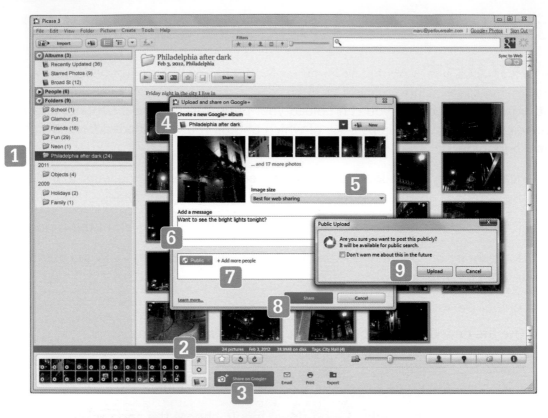

10 Click View Online to view your newly uploaded photos on Google+.

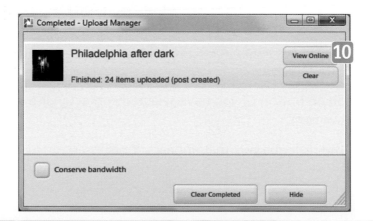

ALERT: Uploading your images at original size counts towards your one gigabyte of free storage space, while uploading your images at Web-optimised size does not.

HOT TIP: Leave the field beneath the Add a message field blank to create a private Google+ album, or one that only you can view.

Tip 10: Order prints online

If you don't own a photo printer, or if you prefer the look and feel of professionally produced prints, you can use Picasa to place a print order with whichever service you choose. However, it's very important that you crop your photos to the desired dimensions before you send the photos off for printing. Find the choice of print dimensions by visiting the service's website.

1 In Picasa's Library view, click a photo to print online.

2 Click the Hold Selected Items button in the tray at the bottom left of the window.

3 Choose File > Order Prints from the main menu.

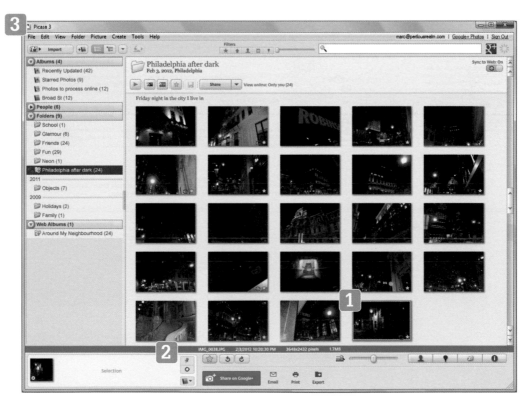

▶ **SEE ALSO:** For details on cropping your photos, see Chapter 7.

🔥 **HOT TIP:** To select all the photos in an album or folder, simply click the album or folder.

4 From the Location drop-down menu, choose where you live.

5 From the list of providers that appears, choose your favourite. Picasa transfers you to this provider's website.

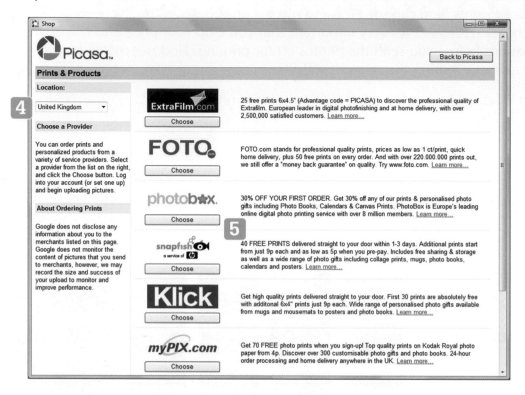

 DID YOU KNOW?

Many providers can put your photos on gift items such as mugs, T-shirts and calendars.

1 Digital photography basics

Introduction

You probably got a digital camera so that you could take some pictures, not set the date and time, charge the batteries, and figure out which way to insert the memory card. Learning how to use a new gadget can quickly become a losing proposition, but this book is here to even the odds. In this chapter, I show you how to set up your camera and make the most of its capabilities depending on how you plan to use it.

Charge your camera

Your digital camera's electronic components require constant power, so you must recharge or replace its batteries on a regular basis. Before you begin, determine what kind of batteries your camera uses: a battery pack, standard rechargeable batteries or standard disposable batteries.

1 Remove the rechargeable batteries or the battery pack from your camera.

2 Place the batteries or the battery pack in the charger according to the instructions in your camera's manual.

3 Plug in the charger and wait for it to do its work. This may take some time.

4 Place the newly charged batteries or battery pack in your camera.

5 Unplug your battery charger and store it somewhere dry and dust-free.

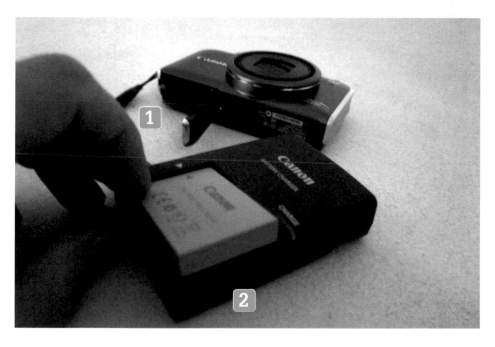

HOT TIP: If your camera runs on disposable batteries, you can purchase a battery charger and rechargeable batteries separately, or you can just continue to feed the camera disposables. To boost performance, try disposable lithium batteries instead of alkalines.

ALERT: Be careful not to keep the batteries in the charger too long. Doing so overcharges the batteries, which wears them out faster.

Install your camera's software

Your digital camera may have come with a CD-ROM containing software for working with your photos. While you can download free – and often better – software from the Web, as you will do later in this chapter, installing the software from the CD-ROM is still a good idea because it provides features specific to your camera that you can't get anywhere else.

1 Place the disc that came with your camera in your computer's CD or DVD drive.

2 Wait for the installation screen to appear.

3 Follow the instructions in the wizard, choosing the default settings when prompted. You can change them later if you like.

4 When installation completes, store the disc in a safe place.

HOT TIP: If the CD-ROM that came with your camera contains only electronic versions of the user guide, you don't need to work through this task.

HOT TIP: The wizard may prompt you to restart your computer after installation. If so, be sure to restart the computer before continuing with this book.

Download and install Picasa

Picasa is free software from Google for organising and editing digital photos on your computer. While you may have received similar software on the CD-ROM that came with your camera, Picasa is often better at the tasks of organising, editing and sharing.

1 Go to http://picasa.google.com/

2 Click the Download Picasa button.

3 Install the software as applicable.

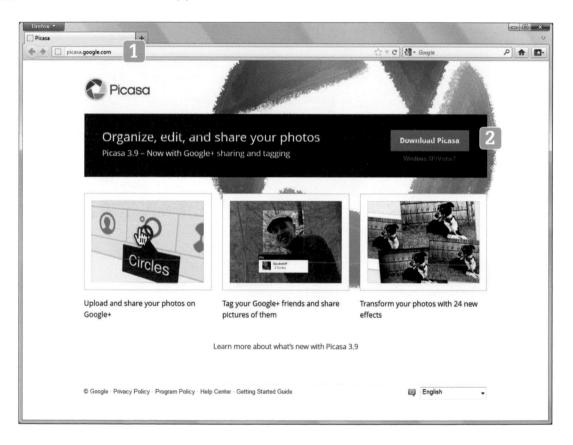

HOT TIP: If you don't download Picasa, you can adapt the examples in this book to fit your software of choice, but doing so requires a degree of familiarity with its capabilities.

HOT TIP: Your browser may ask you for verification before downloading Picasa.

Insert a memory card

Your digital camera stores photographs electronically, just like a computer. To augment your camera's built-in storage space, you can purchase memory cards. There are several different types of cards available, and many will not work with your particular camera, so check your camera's manual if you aren't sure which kind to buy.

1 Find the memory card slot on the camera.

2 Insert the memory card in the slot.

3 If this is the first time that you are using the memory card, you should format it. Refer to your camera's manual for the exact procedure.

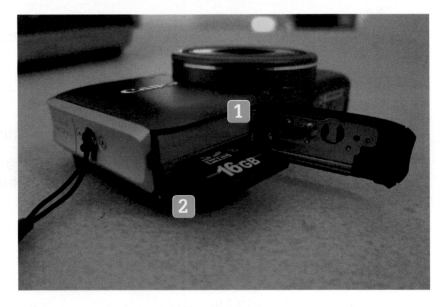

WHAT DOES THIS MEAN?

Format: Formatting the memory card makes the card ready to work with your specific type of camera. This procedure also erases the entire contents of the memory card.

 HOT TIP: It's smart to carry several memory cards with you on long trips. When one card fills up, you can pop it out, store it in a safe place and pop in a new card.

 ALERT: Some types of memory cards, such as SD, include a physical switch for locking the contents of the card. If your memory card does not seem to be storing images, make sure this switch is set to its Unlocked position.

Set the capture format

The capture format of your digital camera determines the type of image file that the camera uses to store the picture. Many cameras offer two or three choices. Depending on which type you select, your photos may look better, especially in prints, but you may not be able to share your photos electronically until after you process the files on your computer.

1 Using your camera's menus, find the setting that controls capture format.

2 Choose JPEG or JPG when the ability to share your photos electronically is more important than getting the maximum image fidelity from your camera.

3 Choose TIFF or TIF when image fidelity is more important than being able to share your photos electronically.

4 Choose RAW to get your camera's very best image fidelity, but you will not be able to view your photos on other electronic devices until after you transfer the photos to your computer.

? DID YOU KNOW?
Cameras from different manufacturers usually have different RAW formats, whereas JPEG and TIFF are standardised, which is why these types of images are easier to share across devices.

HOT TIP: Some cameras enable you to capture RAW and JPEG images simultaneously – an attractive option if you have a large-capacity memory card.

Set the picture quality

Picture quality in digital photography refers to the amount of digital information that the photo contains. The greater the information in the photo, the better it tends to look but the more space it takes up on the memory card. It's up to you to decide whether you want to shoot more lower-quality photos or fewer higher-quality ones.

1 Using your camera's menus, find the setting that controls picture quality.

2 Choose Good or Standard quality for images that you do not plan to print; these images often contain visible *artifacts* or defects when you look closely.

3 Choose Better or High quality for images that you plan to print as snapshots.

4 Choose Best or Super-high quality for images that you plan to print at larger-than-snapshot size.

 HOT TIP: Changing the picture quality does not affect the quality of the photos that you have already taken.

 HOT TIP: It's better to take photos at the lowest quality setting and risk getting some artifacts than to miss once-in-a-lifetime photo opportunities.

Set the picture size

Picture size refers not to the physical dimensions of a photo but rather to its *aspect ratio,* or the proportion of its width to its height. When your digital camera gives you a choice, you should specify the desired picture size before you start shooting, depending on how you intend to display your photos afterwards.

1 Using your camera's menus, find the setting that controls picture size.

2 Choose 3:2 to shoot photos that you intend to print.

3 Choose 4:3 to shoot photos that you intend to display on a standard-definition TV or monitor.

4 Choose 16:9 to shoot photos that you intend to display on a high-definition TV or widescreen monitor.

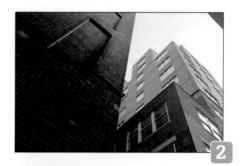

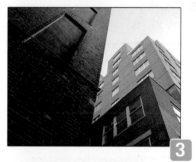

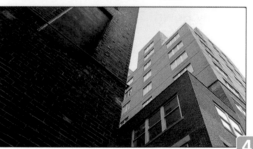

? DID YOU KNOW?
The default aspect ratio for most digital cameras is 4:3.

HOT TIP: Even if your camera shoots at a single aspect ratio, you can easily crop or stretch any digital photo to fit the desired dimensions once you get the photo onto your computer.

HOT TIP: You can make prints from photos captured in 4:3 or 16:9, but consider printing them at home, where you can better control the position of the image on the paper. If you use a commercial printing service, your prints will probably come back cropped.

Take your first picture

Now that you have charged the batteries, loaded a memory card and selected the format, quality and size of your images, it's time to take a photo.

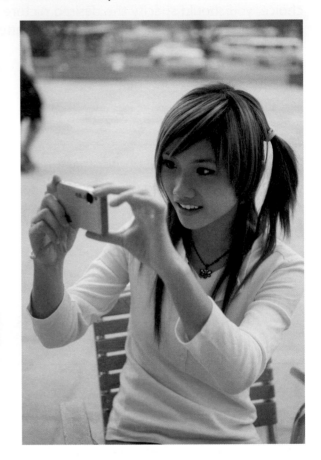

1 Set your camera to Capture or Shooting mode.

2 Choose a location. If you're indoors, make sure there is plenty of light.

3 Choose a subject that isn't too far away, say about 3 metres from the camera lens.

4 Assume a steady but comfortable stance.

5 Point the lens at the subject, and use your camera's viewfinder or LCD display to frame the shot.

6 Press the shutter release halfway down. Your camera adjusts the focus and exposure level of the frame.

7 Press the shutter release the rest of the way down. The camera captures the image.

ALERT: If your camera has a lens cap, make sure that you remove it now.

SEE ALSO: For more information on composing the shot, see Chapter 4.

 HOT TIP: To avoid shaking your camera, don't hold it too tightly.

Review the pictures stored in your camera

One advantage to digital photography is that you can review your photos instantaneously. All the photos in your camera's internal memory or memory card are available for your perusal at any time.

1 Switch your camera to Review or Playback mode.

2 To step through the stored pictures, press the arrow buttons:

 a Press the right-arrow button to proceed to the next photo.

 b Press the left-arrow button to go back to the previous photo.

3 To delete the current photo, press the Delete button.

4 When you have finished reviewing pictures, switch your camera back to Capture or Shooting mode.

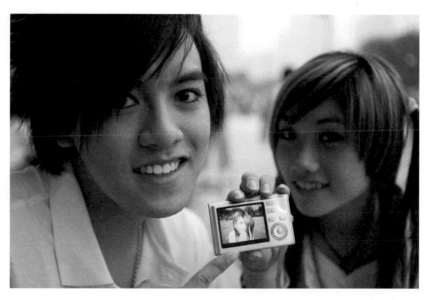

 HOT TIP: Running the display puts a significant drain on your camera's batteries, so use this feature judiciously.

ALERT: Each photo is irreplaceable. It's always better to keep a photo that you know you don't need than it is to delete a photo that you might miss later.

Care for your camera

The lens is the most critical component of any camera, digital or otherwise, not to mention the most difficult and expensive to replace, so you need to keep yours in excellent condition. But since your digital camera is also an electronic device, it's a bit more temperamental about the prevailing weather conditions than its mechanical predecessor. To prolong its life, try these simple precautions:

1 Hold the lens under a strong light. If the surface is dusty, wipe it gently with a clean, dry cloth.

2 Use a clean, dry cloth to wipe off your camera's display.

3 Wipe dust from the flash bulb with a cotton swab.

4 Avoid using the camera for more than a few seconds at a time in rainy weather.

5 Avoid subjecting the camera to excessive heat or cold.

6 Keep the camera out of sustained, direct sunlight.

7 Consider purchasing some accessories:

 a Get a lens cap for your camera's lens.

 b Get a padded camera bag that fits your camera snugly.

 c Get a wrist or neck strap to attach to your camera.

8 Avoid taking photos of celebrities with bodyguards!

 HOT TIP: If you notice rain spots or small smudges on the lens, try a few drops of a mild glass cleaner.

! ALERT: Do not submerge your camera for any reason unless it is specifically designed for underwater use.

2 Use automatic settings

Introduction

Your digital camera does everything except take its own photos – and some digital cameras even do that. Focus, exposure, shutter speed, aperture size: all these variables and more are automated, so that if you don't want to think about them, you don't need to. In this chapter, I discuss many of these automatic settings, and I suggest easy ways to improve their performance according to your shooting conditions.

Use autofocus

Autofocus or *AF* is your digital camera's system for making subjects appear sharply in your photos. Your camera recognises a number of focus zones: sometimes 5, sometimes 9, sometimes 11 or more. Where the subject falls in relation to these zones determines how the autofocus adjusts the lens to achieve the ideal level of sharpness in the image.

1 Using your camera's menus, find the autofocus settings.

2 Set the type of autofocus:

 a Choose Single when both you and the subject are stationary.

 b Choose Continuous when either you or the subject are moving.

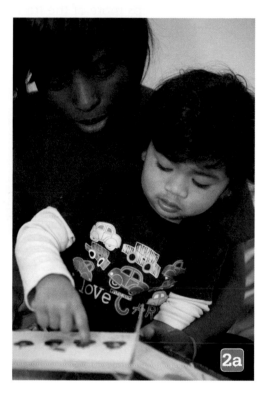

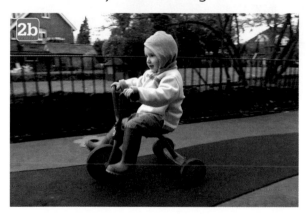

3 Choose how to handle your camera's focus zones:

 a Choose All Targets or AI to let the camera decide which zone to focus on.

 b Choose Single Target, Spot or Center when your subject is surrounded by scenery; be sure to place the subject in the focus zone indicated by the display.

HOT TIP: Your camera might also have Tracking AF, which is an ideal setting for moving subjects.

4 If your camera has optical zoom, you may be able to set the focus distance:

a Choose Short for low depth of field, which focuses on nearby subjects and blurs the background.

b Choose Long for high depth of field, which keeps more of the frame in focus.

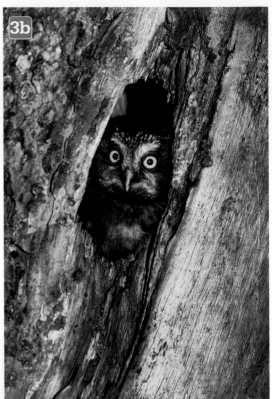

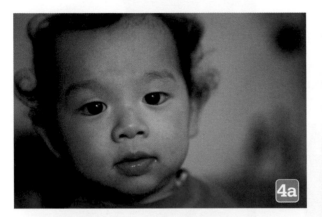

 HOT TIP: If your camera has a Macro focus mode, use this mode to take close-up shots of small subjects.

Use face detection

Face detection (face priority or face recognition) is a special autofocus setting in your camera that scans the frame for what appears to be a face and adjusts the lens to focus upon it. Use this setting specifically for shooting people's faces – it doesn't work well with animal faces.

1 Find the autofocus or AF settings in your camera's menus.

2 Select the face detection setting.

3 When you have finished shooting faces, switch the autofocus back to a general-purpose setting, such as All Targets.

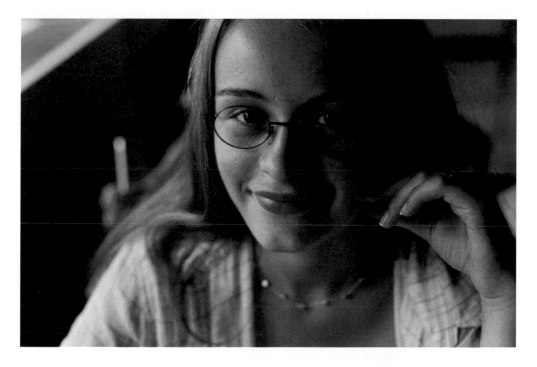

 HOT TIP: When the camera detects multiple faces, it usually focuses upon the one nearest the lens.

 HOT TIP: You can use Face Priority for photographing the faces of statues and even the faces in paintings and in other photos.

Use auto flash

Auto flash is the system in your digital camera that controls when and how the flash bulb fires. Your camera's light meter measures ambient light, and if the amount drops below a certain threshold, the flash goes off. You can modify the behaviour of auto flash to improve the quality of the light in your photos whenever the situation calls for it.

1. Find the auto flash settings in your camera's menus. Watch out for the abbreviation AF: that usually stands for autofocus, not auto flash.

2. Set the flash mode:

 a. Choose Auto for general-purpose auto flash.

 b. Choose Always or Fill Flash when the subject is lit from behind or positioned in the shade.

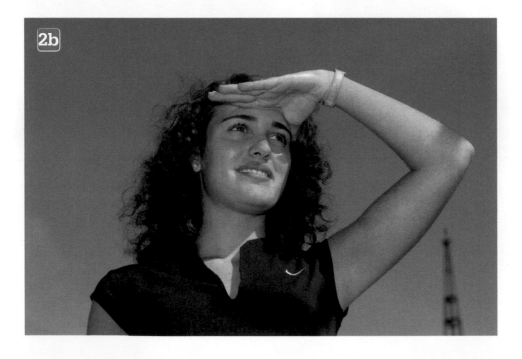

 HOT TIP: Not all cameras come with a built-in flash, but you may be able to buy a separate flash unit to attach to the camera.

3 Set the intensity or output of the flash, which controls the flash's brightness:

a Increase the intensity to up the level of contrast in the shot, which can make very small or distant subjects appear more vivid.

b Decrease the intensity to make the light of indoor shots appear more realistic.

Reduce red-eye

Red-eye is the phenomenon in photography where the usually pleasant eyes of the people in your tribe take on a rather disconcerting red hue. Your digital camera can help to eliminate red-eye from your photos by firing a series of flashes or lighting a lamp designed specifically for this purpose.

1 Using your camera's menus, find the auto flash settings.

2 Select the Red-eye Reduction setting.

3 After you take the shot, return the camera to a general-purpose flash mode, such as Auto.

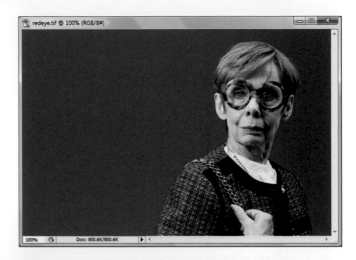

? DID YOU KNOW?

Red-eye happens when the camera captures reflected light from your subject's retina.

 HOT TIP: For best results, make sure that your subject looks directly at the flash or the red-eye lamp.

 HOT TIP: Pets are subject to red-eye in a variety of hues. But no matter what unnatural colour their eyes might turn, the Red-eye Reduction setting can help to correct it.

! ALERT: Don't confuse Red-eye Reduction mode with Red-eye Correction mode. Red-eye Correction is a form of image processing better left to your computer.

Use auto exposure

Auto exposure or *AE* is your digital camera's system of controlling the amount of light that reaches the photosensitive sensor, which is the part of the camera that captures the image. Your camera divides the frame into perhaps hundreds of different metering areas, and it analyses the differences in brightness among them to determine how best to capture your subject.

1 Find your camera's auto exposure or AE controls.

2 Set the exposure compensation:

 a Increase the exposure compensation to make the photo brighter or to make bright objects appear closer to their natural colours.

 b Decrease the exposure compensation to make the photo darker.

SEE ALSO: Your camera may provide Priority AE modes, including Av or Aperture Priority and Tv or Shutter Priority. These modes are partially manual – see Chapter 3 for more information on them.

3 Set the metering mode:

a Choose Digital or Evaluative to monitor light levels across all metering areas – a fine setting for general use.

b Choose Center Weighted Average to help filter out background light.

c Choose Spot to counteract very strong backlight. Be sure to place your subject in the metering area indicated by the display.

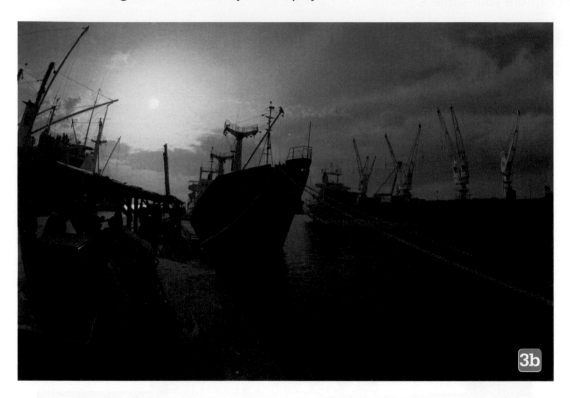

3b

Use auto white balance

Auto white balance or *WB* is your digital camera's system for removing odd tints or colour casts from your photos. It works by scanning the frame for objects that appear to be white or nearly white and then shifting these tones so that they show up as white in the photo. If there are no white objects anywhere in the frame, your camera might get confused, but you can often help it out by changing the WB setting.

1 Using your camera's menus, find the auto white balance or WB settings.

2 Set the white balance mode:

a Choose Auto to let the camera determine what is white. This is the general-purpose setting.

b Choose Day or 5300K to shoot outdoors on a sunny day.

c Choose Cloudy or 6000K to shoot outdoors on a cloudy day.

d Choose Tungsten or 3000K to shoot indoors under tungsten light bulbs.

e Choose Fluorescent or 4000K to shoot indoors under fluorescent light bulbs.

f Choose Fluorescent H or 6600K to shoot indoors under daylight-fluorescent light bulbs.

2c

2d

? DID YOU KNOW?
The K rating indicates colour temperature, which describes the colour that certain kinds of objects would glow if you were to heat them to this many degrees Kelvin.

! ALERT: Your camera might have an Underwater setting for white balance, but never submerge your camera unless it has been specially designed for underwater use.

Use Scene modes

Your digital camera's Scene or SCN modes provide a quick way to adjust a variety of camera settings, including focus, exposure and white balance, according to common locations (Beach), subjects (Fireworks) or shooting conditions (Night). Scene modes often give you better photos than your camera's general settings for the types of situations that these modes describe.

1 Find the Scene or SCN controls on your camera.

2 Choose the mode that best describes your current shooting conditions or the subject of your photo.

3 After taking the shot, return the camera to its normal setting.

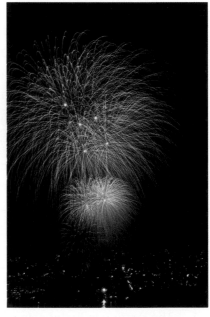

Use the self-timer

Your digital camera's self-timer enables you to include yourself as a photographic subject. The timer counts down while you move into position and snaps the shot when the count reaches zero.

1 Mount the camera on a firm surface. A tripod is ideal.

2 Find the self-timer control on your camera and turn it on.

3 Choose a setting for the timer length, if applicable.

4 Press the shutter release and move into position in front of the lens. Don't forget to smile!

5 After the camera takes the shot, remember to turn off the self-timer.

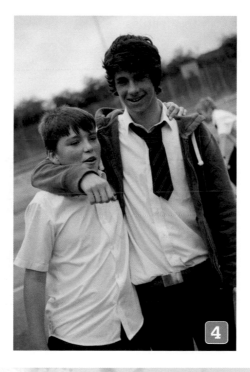

 HOT TIP: In addition to preset lengths, your camera may include a Custom setting, which enables you to set any of a range of times.

Take continuous shots

Under normal conditions, pressing the shutter release squeezes off a single frame, which translates into a single photo. If your camera includes a Continuous or Sequential shooting mode, also known as Burst, you can hold down the shutter release to capture an entire sequence of photos.

1 Insert a high-speed, large-capacity memory card in your camera.

2 Turn off your camera's flash as required, and make sure you compensate with plenty of ambient light or by increasing the exposure level.

3 Find the Continuous shooting mode in your camera's menus and turn on this feature.

4 When you have finished shooting, return the camera to Single or Single Frame mode.

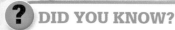

? DID YOU KNOW?

On many cameras, Continuous mode shoots at about three frames per second. By comparison, cinema photography flickers by at 24 frames per second.

! ALERT: Some cameras have an upper limit to the number of images that you can capture in Burst mode, regardless of the amount of storage space available.

Stabilise the image

Most digital cameras include at least one *image stabilisation* or *IS* system to counteract the effects of camera jitters, which could otherwise make your photos come out looking blurry. You will want to keep this setting turned on whenever you hold the camera by hand, but feel free to turn it off when you mount the camera on a tripod.

1 Using your camera's menus, find the image stabiliser settings.

2 Choose a setting:

 a Choose On or Continuous whenever you hold the camera by hand.

 b Choose Shooting to engage image stabilisation only when you press the shutter release. This mode conserves a small amount of battery power.

 c Choose Panning when you want image stabilisation but you also intend to pan the camera, for example while tracking a moving subject.

 d Choose Off when you mount the camera on a tripod.

3 When you've finished, revert the camera to Continuous or Shooting mode.

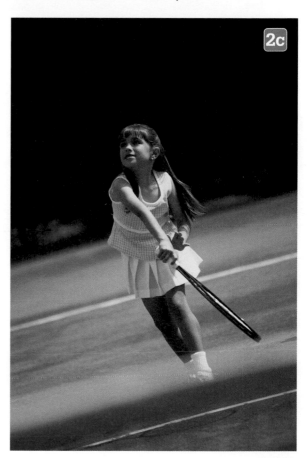

2c

 HOT TIP: Lots of zoom, low light and low shutter speeds can also increase the effect of jitters in your photos. If your camera's IS isn't keeping up, try alleviating these other factors.

 DID YOU KNOW? Some cameras can stabilise both horizontal and vertical panning, while others stabilise panning in one direction only.

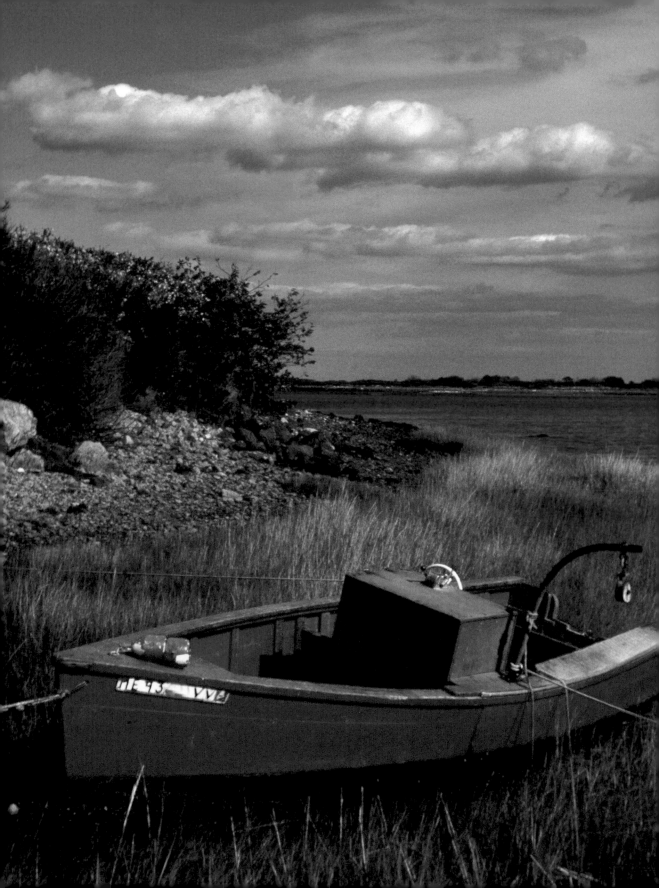

3 Use manual settings

Introduction

Automatic settings aren't the answer to everything. Even after you've adjusted them for your shooting conditions, they still might give you less than stellar results. But many digital cameras provide manual control – not just for the zoom but also for the focus, exposure and white balance of your shots. Manual settings are for the adventurous, it's true, but once you've got the hang of them, you'll wonder why you ever trusted the auto-this and auto-that. This chapter helps to get you started.

Use the zoom

The Zoom control on your digital camera makes faraway subjects appear closer. Many digital cameras offer two kinds of zoom: optical and digital. Optical zoom helps to reveal fine detail and it doesn't degrade image quality at all, although it does tend to flatten perspective. By comparison, digital zoom is a form of image processing that does not reveal any new detail in the image; in fact, it can introduce a noticeable loss of clarity, even at moderate levels.

1 Find the Zoom control on your camera. It may be one of the rings around the lens, or it may be a lever or a set of buttons.

2 Experiment with this control to see how it affects the amount of zoom in the shot.

3 If your camera offers both optical and digital zoom, and if your camera engages digital zoom automatically, find the digital zoom setting in your camera's menus:

 a Turn digital zoom on if you don't mind some loss of image quality when you exceed your camera's optical zoom rating.

 b Turn digital zoom off if you don't want to risk loss of image quality at the expense of some extra magnification.

? DID YOU KNOW?
The best substitute for zoom is simply walking closer to your subject. It achieves the same result as optical zoom.

🔥 HOT TIP: Apply your own digital zoom in image-editing software by blowing up the image and then cropping it.

Use manual focus

Your digital camera's autofocus feature doesn't always provide satisfactory results. Maybe the subject is too small or too far away, or maybe there are too many other objects in the frame. Or maybe you want to soften the focus intentionally to invoke a particular mood. In cases like these, you may be able to set your camera to *manual focus,* or *MF,* and focus the shot by hand.

1 Find the manual focus control on your camera. You might have a dial setting for MF, or you might need to turn off autofocus or AF.

2 Find the part of the camera that adjusts focus in MF mode. It might be the dial that surrounds the OK or Set button, or it might be one of the rings around the lens barrel.

3 Turn this control one way or the other to bring the subject in and out of focus.

 HOT TIP: While using MF mode, you may be able to engage autofocus to help you fine-tune the focus of your shot. Consult your camera's manual for details.

Set the shutter speed

The *shutter speed* setting of your digital camera determines how long the lens shutter remains open. Increasing the shutter speed value keeps the shutter open longer, which increases the exposure level and improves low-light shots, although moving subjects can easily blur, and your photos are highly susceptible to jitter. Always use a tripod in combination with increased shutter speed values.

1 Choose an exposure mode that gives you control over shutter speed:

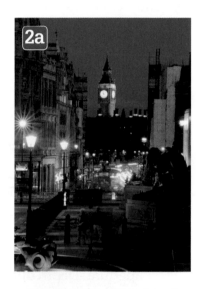

a Choose Shutter Priority or Tv if you wish to adjust the shutter speed but leave the aperture size to the camera.

b Choose Manual Exposure or M if you wish to adjust both the shutter speed and the aperture size.

2 Change the shutter speed value:

a Increase this value to take better photos under low-light conditions, but don't forget to use a tripod.

b Decrease this value to capture moving subjects in detail and clarity but with a shorter exposure.

3 If you are using Manual Exposure mode, adjust the aperture size value in the same direction by the same number of stops to compensate for the longer or shorter exposure.

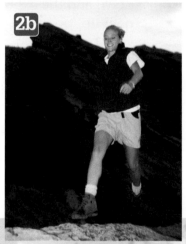

? DID YOU KNOW?
Tv stands for time value, which refers to how long the shutter remains open.

Set the aperture size

The *aperture size* or *f-stop* setting of your digital camera controls the diameter of your camera's aperture, which works rather like the pupil of your eye. A wider aperture lets in more light while simultaneously decreasing depth of field, causing the background of the photo to blur.

1 Choose an exposure mode that gives you control over aperture size:

 a Choose Aperture Priority or Av if you wish to adjust the aperture size but leave the shutter speed to the camera.

 b Choose Manual Exposure or M if you wish to adjust both the aperture size and shutter speed.

2 Change the aperture size value:

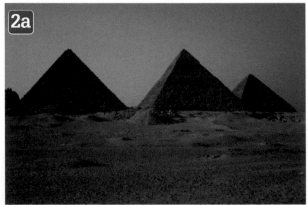

 a Increase this value to narrow the aperture. Depth of field goes up and the exposure level goes down.

 b Decrease this value to widen the aperture. Depth of field goes down and the exposure level goes up.

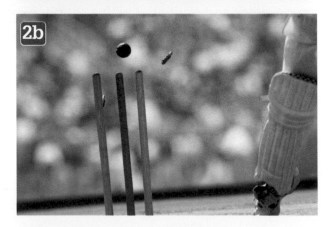

3 If you are using Manual Exposure mode, adjust the shutter speed in the same direction by the same number of stops to compensate for the lower or higher exposure level.

WHAT DOES THIS MEAN?

Depth of field: This describes how much of a photo is in focus.

? DID YOU KNOW?

The F in *f-stop* stands for focal ratio. As the f-stop value increases, the diameter of the aperture decreases.

Set the ISO speed

In a digital camera, *ISO speed* measures the light sensitivity of the photographic sensor. Increasing the ISO speed gives you better exposure under darker conditions, but you may also introduce *noise* or grain into the image. Regardless, ISO speed acts as a failsafe for other kinds of manual adjustments. Suppose that your friends are running willy-nilly in the streets, so you shorten the shutter speed to freeze them in action. But shortening the shutter speed makes exposure go down. To bring it back up, you could widen the aperture, but that would also reduce the depth of field, so parts of the frame might appear out of focus. But if you increase the ISO speed instead, you can leave the aperture value alone while compensating for the lower exposure.

1 Using your camera's menus, find the setting for ISO speed.

2 Adjust the ISO speed:

 a Increase this value if you are shooting under very dark conditions or if you need to compensate for a shorter shutter speed or a wider aperture.

 b Decrease this value if you are shooting under very bright conditions or if you need to compensate for a longer shutter speed or a narrower aperture.

3 Take a practice shot under current conditions:

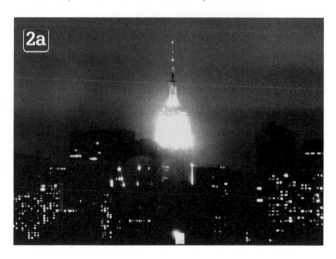

 a If the image is too dark or too bright, make further adjustments to ISO speed.

 b If the image has too much noise, you can decrease the ISO speed, but then you should also keep the shutter open longer or widen the aperture.

? DID YOU KNOW?

Your camera's ISO stops come from the International Organization for Standardization's ratings for the sensitivity of photographic film.

HOT TIP: Noise isn't always bad. You might use it intentionally for creative effect.

Set manual white balance

Normally your digital camera's auto white balance ensures that what looks like white to your eye shows up as white in your photos. Under difficult lighting, though, your camera might slip up. When adjusting the automatic setting doesn't work, you may be able to assume manual control over white balance.

1 Using your camera's menus, find the manual or custom white balance setting.

2 Point the camera at something well lit and white or slightly grey, such as a blank piece of paper under normal lighting conditions, or a polar bear on an ice floe.

3 Snap the shutter release.

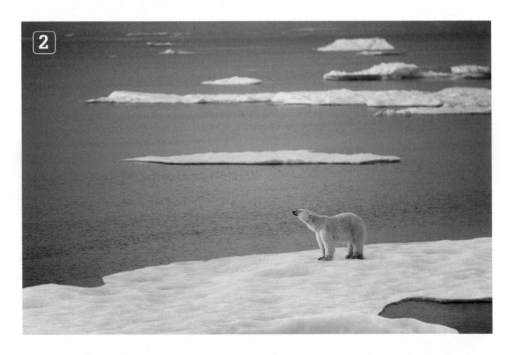

 HOT TIP: You should recalibrate your camera's manual white balance as lighting conditions change.

 DID YOU KNOW?
Professional photographers often carry around neutral grey reference cards for precisely this purpose.

Use colour modes

Left to its own devices, your digital camera attempts to reproduce the colours of the world exactly as they appear to your eye. But perhaps you want to remember your weekend getaway as being more colourful than it actually was, or perhaps you want to experiment with black-and-white or antique-style photography. If so, you can explore your camera's colour modes.

1 Find the colour modes in your camera's menus. They might appear under Picture Mode or Color Settings.

2 Choose a colour mode:

 a Choose Natural or Basic to apply no colour modification.

 b Choose Vivid to get higher saturation or brighter colour.

 c Choose Muted or Neutral to get lower saturation or less vivid colour.

 d Choose Sepia for a brown-and-white, turn-of-the-twentieth-century feel.

 e Choose Black & White or Monotone to photograph in black and white.

3 After you have taken the shot, switch the camera back to the Natural or Basic colour mode.

 HOT TIP: Processing colour on your computer usually yields better results and it doesn't affect the colour of your original photos in case you change your mind later.

Use Panorama mode

Many digital cameras include a Panorama or Stitch Assist mode for piecing together very wide or very tall images from a sequence of several individual shots. In one kind of Panorama mode, the camera stores the component photos normally; you transfer them to your computer and assemble or *stitch* them together in your camera's software. In the other kind of Panorama mode, the camera assembles the photos automatically and presents you with the composite shot.

1 Find a place to stand where you can pivot or lean without otherwise changing your position.

2 Find and activate your camera's Panorama mode.

3 Assuming that you start on the left, take the first picture in the sequence.

4 Look at the display and line up the next shot in the sequence so that its left edge overlaps the right edge of the previous shot.

5 Continue adding pictures to the sequence, or end the sequence according to the instructions in your camera's manual.

6 If your camera requires you to stitch together your panorama shots manually, transfer these photos to your computer and use your camera's software to assemble the pieces.

HOT TIP: You can create a panorama from any set of photos using image-editing software. Turn off your camera's flash and try to place landmarks near the edges of the photos; this helps you to align them better in the software.

4 Get the best shot possible

Introduction

You wouldn't guess it from fussing over apertures and shutter speeds, but photography is supposed to be an expressive medium. Your photos reveal something about how you perceive the world, and your best ones encourage others to share in that perspective. Whether you're out to make an artistic statement or simply to document your life and times, your photography can benefit from some easy techniques, which I'll talk about in this chapter.

Consider how to focus the shot

Focus helps to draw attention to the subject of your photos. But good photography is just as much about what *isn't* in focus in any particular shot. Knowing when and how to blur the background can be one of your most effective techniques.

1 If you are taking a portrait or a close-up, draw attention to the subject with a shallow depth of field. Do one of the following:

 a Use the Portrait Scene mode.

 b Increase the amount of optical zoom.

 c Decrease the aperture size value (which widens the aperture).

 d Shoot against a neutral background.

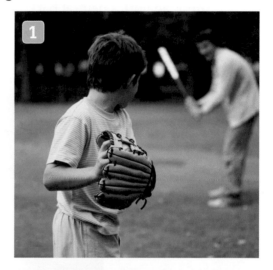

2 If you are taking a landscape, keep more of the frame in focus with a long depth of field. Do one of the following:

 a Use the Landscape Scene mode.

 b Decrease the amount of optical zoom.

 c Increase the aperture size value (which narrows the aperture).

3 If you adjusted the aperture size using Manual Exposure mode, adjust the shutter speed or the ISO speed to compensate for the greater or lesser exposure level.

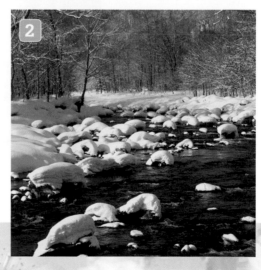

 HOT TIP: If you use optical zoom to manipulate depth of field, don't change your position or you could cancel out the effect.

Consider how to frame the shot

Among professional photographers, *framing* usually means the distance of the camera from the subject. How you frame the shot helps to determine where the attention goes.

1. To emphasise a subject's facial expression or emotions, use a *close-up*:

 a Show no more than the subject's face and shoulders.

 b Shoot against a neutral background, or blur the background with shallow depth of field.

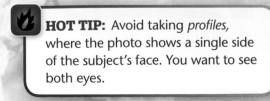

HOT TIP: Avoid taking *profiles*, where the photo shows a single side of the subject's face. You want to see both eyes.

2 To emphasise what the subject is doing or where the subject is, use a *medium shot*:

 a Show the subject's head and torso.

 b Avoid a busy background, but increase the depth of field to bring more of it into focus.

3 To emphasise the setting or action rather than the person involved, use a *long shot*:

 a Show the subject's entire body.

 b Use a long depth of field, but watch out for potential distractions throughout the frame.

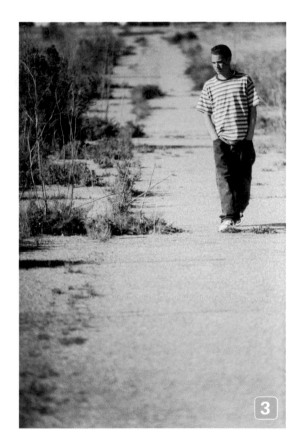

Consider the quality of the light

Good photography takes into account not just the level of exposure but also the quality of the light. *Soft light*, like the light from a shaded lamp, feels warmer and more natural, and it tends to smooth out surface textures. *Hard light*, like the light from your flash, is cooler and more clinical. It helps to reveal detail, but it also brings out all the little flaws – an unflattering choice for portrait photography.

1 For a more flattering portrait, soften the light:

 a When outdoors, look for slightly overcast weather or areas of open shade.

 b When indoors, bounce the light off a surface instead of illuminating your subject directly.

 c Move the subject closer to the light source.

 d Indoors or out, use Fill Flash mode to help soften shadows on facial features.

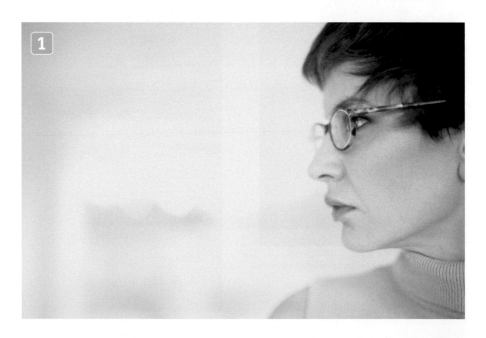

? DID YOU KNOW?

The softness of a light source depends on its size relative to the size of the subject, not its brightness. The larger the relative size, the softer the light.

2 To bring out textures and shapes, harden the light:

 a When outdoors, place the subject in the sunshine.

 b When indoors, shine the light directly on your subject, but be careful about where the shadow falls.

 c Move the subject further away from the light source.

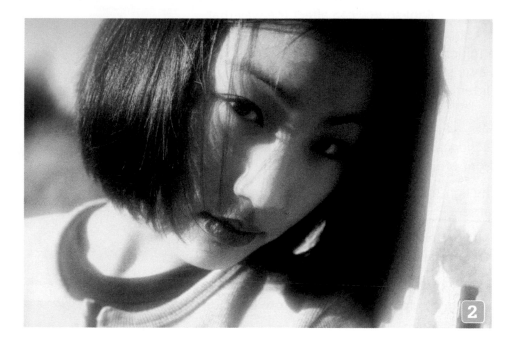

HOT TIP: For the softest light out of doors, try shooting at sunrise or sunset.

Consider the direction of the light

Where the light is coming from is often as important as how much of it there is. The position of the subject in relation to the light source can affect the way that the subject is perceived. The direction of the light also determines the direction of shadows; shadows can lend a sense of depth to your photo, but they can also litter it with distraction.

1 For safe, all-purpose photography, consider *frontlighting*, where the light source illuminates the front of the subject:

 a The light casts shadows away from the camera.

 b The light reveals fewer details but can also make the subject appear flat.

2 For more expressive portraits, consider *sidelighting*, where the light comes from one side of the subject:

 a The light reveals more detail and texture.

 b Facial features appear in more depth, since part of the face is in shadow.

 c Mind the shadows – you don't want them billowing across the walls.

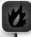 **HOT TIP:** Take care to soften sidelighting with your camera's Fill Flash mode.

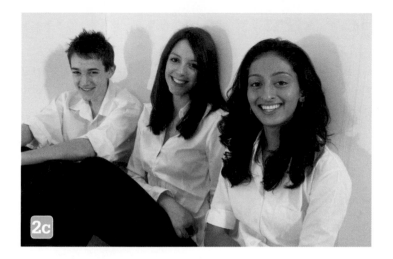

2c

3 For dramatic effect, consider *backlighting*, where the light comes from behind the subject:

 a The light creates a halo around the subject and translucent subjects appear to glow.

 b The front of the subject might appear in silhouette.

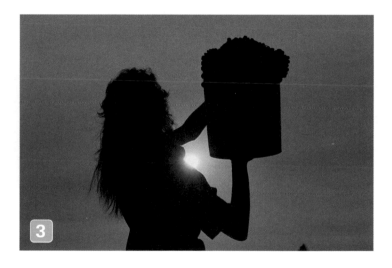

3

 HOT TIP: Avoid flares and other undesirable lighting effects by framing the backlit subject in close-up.

Consider your point of view

The *point of view* in photography is the placement of the camera in relation to the subject. Choosing to look down or look up (or look directly at the subject) can help you to convey moods or suggest attitudes and opinions.

1 Place the camera below the subject, looking up, for a *low-angle shot*:

 a Emphasise the height of a tall structure.

 b Convey a sense of strength, purpose or hopefulness.

 c Increase the sense of motion.

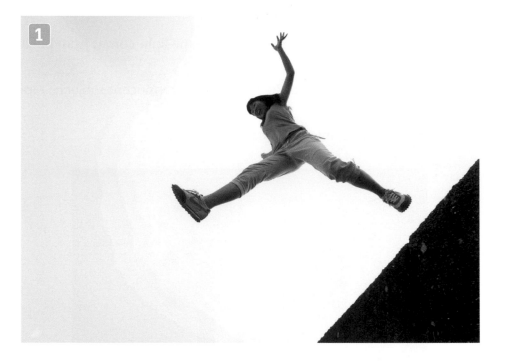

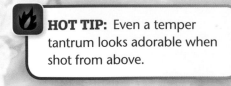

HOT TIP: Even a temper tantrum looks adorable when shot from above.

2 Place the camera above the subject, looking down, for a *high-angle shot*:

 a Emphasise the cuteness or smallness of the subject at the expense of the subject's expressions and actions.

 b Convey a sense of vulnerability.

 c Decrease the sense of motion.

3 Place the camera so that it is roughly the same height as the subject's eyes for an *eye-level shot*:

 a Emphasise what the subject is doing.

 b Emphasise facial expressions.

 c Avoid the bias of low and high angles.

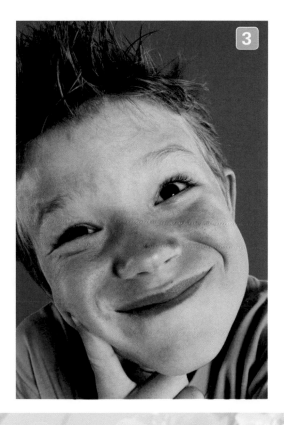

HOT TIP: Slant the angle of your point of view to suggest heightened urgency or energy. This technique is called the *Dutch tilt*.

Use the rule of thirds

The *rule of thirds* is a compositional technique that lends a sense of motion or action to a photo. Instead of centring the subject, you place the subject at an intersection of the lines in an imaginary grid. The extra space on one side of the subject tilts the balance of the shot, so that the subject feels as though it is on the move.

1. Imagine that your camera's display is divided into nine equal rectangular areas on a 3 × 3 grid.

2. Position the subject so that it falls at or near any intersection point of the grid lines.

3. Take the picture.

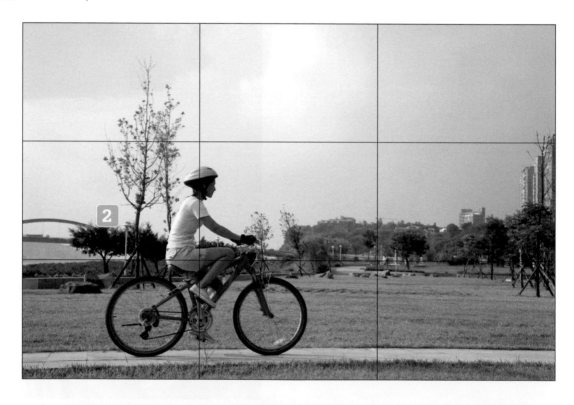

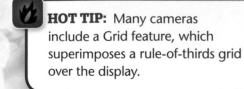
HOT TIP: Many cameras include a Grid feature, which superimposes a rule-of-thirds grid over the display.

Use dynamic symmetry

Dynamic symmetry is a compositional technique based on logarithmic spirals, like the ones in seashells. According to theory, we find such arrangements intrinsically pleasing because of their abundance in nature. By composing your shots along a similar principle, you can make your photos more readily appealing.

1 Draw an imaginary diagonal line from the top left corner of your camera's display to the bottom right corner.

2 Draw a perpendicular line from the diagonal to either the bottom left corner or the top right corner of the display, creating a slanted (or slanted and inverted) T shape.

3 Position the subject so that it falls at or near the intersection of the diagonal and perpendicular lines.

4 Take the picture.

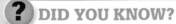

? DID YOU KNOW?
The golden ratio, which is related to logarithmic spirals, very often describes the proportions of a supermodel's facial features.

HOT TIP: Feel free to reverse the directions.

Tell one story at a time

A picture might well be worth a thousand words, but what are those thousand words describing? Do they work together to tell a coherent story, or are they interrupted with commentary, asides and distractions? Framing your shot so that it shows exactly what you intend to shoot (and nothing that you don't) helps you to tighten up the story that it tells, which improves the impact of the photo.

1 Decide exactly what you want to capture.

2 Fill the frame with the subject of your photo:

 a For a portrait, move in close and soften the focus of the background.

 b For a landscape, step well back and avoid including extraneous objects in the extreme foreground.

 c As much as possible, exclude anything from the frame that doesn't contribute to the story that you want to tell.

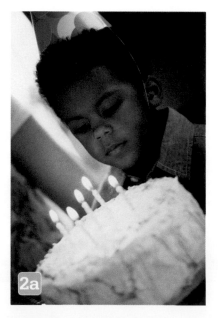

2a

HOT TIP: This is not the time for modesty or diplomacy. Don't shoot the family gathered around the birthday cake when what you're most interested in is your nephew blowing out the candles.

3 When there is a lot of action going on, decide how best to handle it:

 a If all the action pertains to a single story, feel free to include it all.

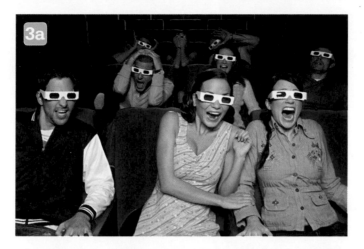

 b If there are multiple stories taking place, shoot a series of photos, one for each story.

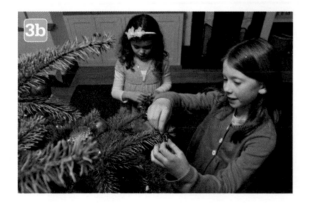

5 Transfer your photos

Introduction

Transferring your photos from your camera to your computer is the first step towards unlocking the many capabilities that make digital photography so attractive. The technology is easier to use than ever before, so reading this chapter may seem superfluous, but I suggest that you work through it just the same. By making a couple of quick preparations beforehand – and by effecting some crucial safeguards afterwards – you'll spend less time troubleshooting technical problems and more time enjoying your digital photos.

Create a photo folder

When considering where to store your photos on your computer, your default Pictures or My Pictures folder makes an excellent candidate. But since you probably store many different kinds of images on your computer, it's a good idea to create a folder specifically for your photos inside Pictures or My Pictures. Not only does this keep your photos separate, it also helps to minimise the clutter in your photo organiser and simplifies the process of creating backups.

1 Find and open the Pictures or My Pictures folder in your computer's operating system.

2 Create a new folder at this location.

3 Rename the new folder as *Photos*.

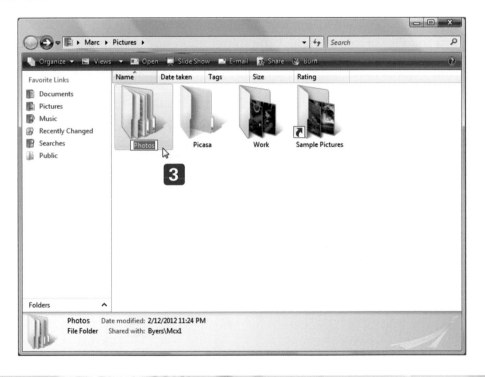

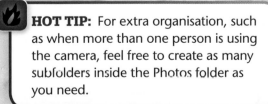

HOT TIP: For extra organisation, such as when more than one person is using the camera, feel free to create as many subfolders inside the Photos folder as you need.

Set up Picasa to work with your photo folder

Now that you have created a special folder for your photos, you can set up Picasa so that it looks for photos in this folder only. This way, when you want to organise your photos, you don't need to wade through all the other image files on your computer.

1 In Picasa, choose Tools > Folder Manager from the main menu.

2 For each of the top-level folders in the Folder List (except for the My Pictures or Pictures folder), select the folder and choose Remove from Picasa.

3 Expand the contents of the My Pictures or Pictures folder by clicking its triangle icon.

4 For each of the subfolders inside My Pictures or Pictures (except for your Photos folder and the Picasa folder), select the folder and choose Remove from Picasa.

5 Select your Photos folder inside My Pictures or Pictures and choose Scan Always.

6 Click OK.

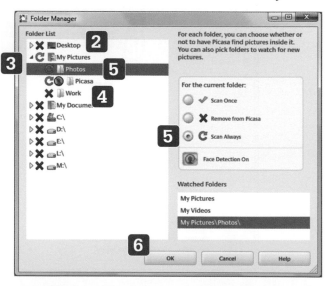

? DID YOU KNOW?

If you haven't used certain features of Picasa yet, you may not have a Picasa folder in My Pictures or Pictures.

HOT TIP: Using a similar procedure, you can set up the software that came with your camera to target your Photos folder specifically instead of your entire Pictures or My Pictures folder.

Create backup sets in Picasa

A *backup set* in Picasa is a running record of which photos you've backed up and which ones you haven't. This feature helps you to create spare copies of all your photos in case something should happen to the originals. In this task, you create two backup sets: one for regular backups and one for long-term archives.

1 In Picasa, choose Tools > Back Up Pictures from the main menu.

2 Click the New Set button.

3 Type *Regular Backup* in the Name field and under Backup type choose Disk-to-disk backup.

4 Click Choose and navigate to a location for the backup files, preferably on an external hard drive or a network drive.

5 Click Make New Folder and set the name of this folder to *Photo Backup.*

6 Click OK to close the folder dialogue box.

7 Under Files to backup, choose All file types.

8 Click Create to make the backup set.

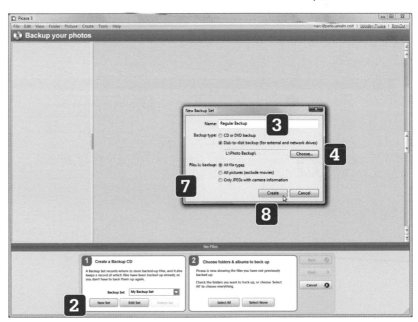

🔥 **HOT TIP:** For best results, you might consider investing in an external hard drive for your backups, but you can also use a network computer or a different folder on the same computer.

▶ **SEE ALSO:** You will make use of these backup sets in 'Make backups of your imported photos' and 'Archive your photos', later in this chapter.

9 Click New Set again and this time create a CD or DVD backup set for all file types called *Archive*.

10 Click Cancel to exit Backup mode without actually backing anything up.

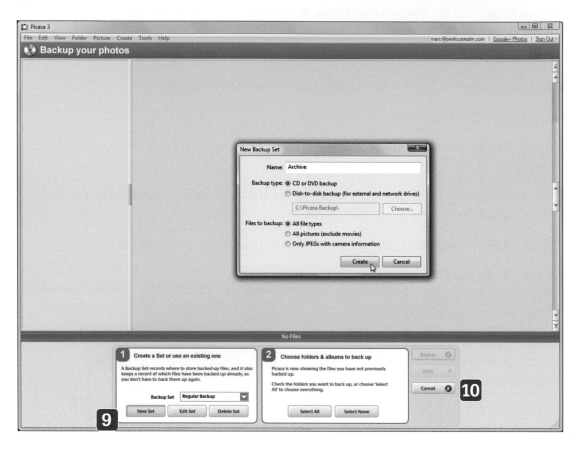

Connect your camera to your computer

Now that you have set up your computer for storing your photos, you can connect your camera to your computer. Before you start, take out the interface cable that came with your camera. In most cases, this is a USB cable, or it may be a FireWire cable; for the connection to work, you must have the same sort of connector port on your computer. In the event of a mismatch, you may be able to buy a converter plug, or you might think about getting a separate memory card reader.

1 Turn off your camera.

2 Plug one end of the interface cable into the output port on your camera.

3 Plug the other end of the interface cable into the corresponding port on your computer.

4 Turn on your camera.

5 If necessary, set your camera to Transfer mode; refer to your camera's manual for details.

6 Import photos according to the instructions later in this chapter.

7 When you have finished, set your camera to Capture mode (if applicable), turn it off and unplug it.

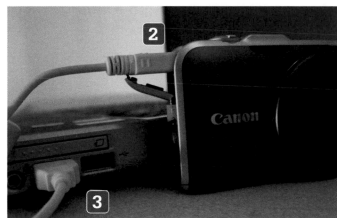

! **ALERT:** Always turn off your camera before you unplug it.

? **DID YOU KNOW?**
Some cameras enable you to connect to your computer wirelessly. If yours does, you don't need to run a cable between the camera and the computer.

HOT TIP: If your computer has a memory card reader, you can transfer your photos directly from the memory card. Simply eject the memory card from your camera and insert it into the card reader.

Import photos into Picasa

With your camera connected to your computer, all that remains is to import the photos. You can import photos by way of your computer's operating system or through specialised software. This task assumes that you're using Picasa, but other software packages follow much the same procedure.

1 In Picasa, click Import.

2 From the Import from drop-down menu, choose your camera.

3 Check the Exclude Duplicates option to prevent Picasa from importing photos that you have already transferred.

4 To mark a photo as a favourite, select the photo and click the Add/Remove star button.

5 To exclude a photo from the import, select the photo and click the Exclude/Include button.

6 From the Import to drop-down menu, choose your Photos folder.

7 In the Folder title field, enter a name for this batch of pictures, or choose one of the presets from the drop-down menu.

8 Decide what to do with the photos on the card by choosing an option from the After Copying drop-down menu.

ALERT: Make sure that you keep your camera turned on throughout the transfer process and that you don't disconnect either end of the interface cable.

9 Import the photos:

 a Click Import All to import all the photos on the card (except for the ones that you excluded in Step 4).

 b Click Import Selected to import only those photos that you have selected.

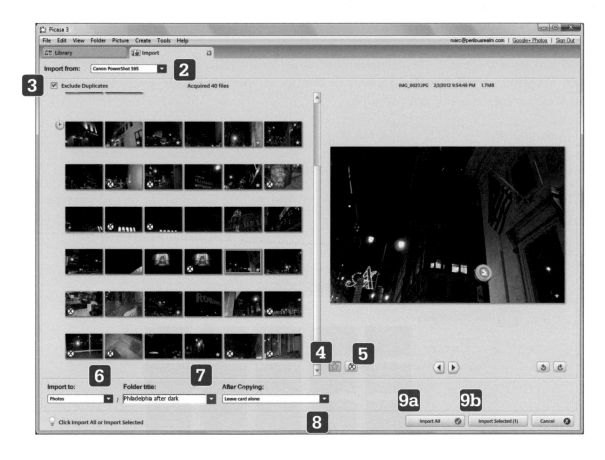

HOT TIP: If you are importing from a memory card reader instead, choose the card reader from the Import from drop-down menu.

Make backups of your imported photos

Backing up your photo files is the single most important task that you'll read about in this entire book. It might feel like a bother – and I won't say it isn't – but compare a few minutes of tedium now against the crushing disappointment that you would feel if you lost your priceless, irreplaceable memories to something as trivial as a technical glitch. As soon as you transfer a batch of photos to your computer, every time, without exception, create a set of backup files.

1 In Picasa, choose Tools > Back Up Pictures.

2 Choose your Regular Backup set from the Backup Set drop-down menu.

3 In the list of folders on the left, tick all the folders that you wish to include in the backup.

4 Click Backup.

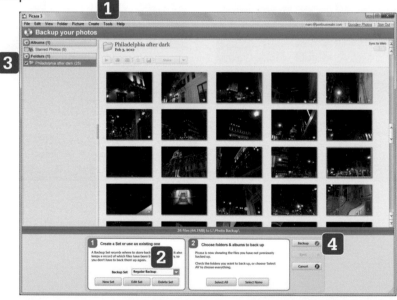

 HOT TIP: Picasa keeps track of which folders you have backed up, so you won't need to back up the same folders more than once.

View your imported photos

It's time to take your first close look at the photos that you have imported. What a difference the computer screen makes! As you go through your shots, you may notice ways that you can improve them, but these considerations can wait for later. For now, sit back and enjoy the show.

1 In Picasa, select the folder that contains the photos that you have just imported.

2 Click the Play Fullscreen Slideshow button.

3 To end the slideshow, press ESC.

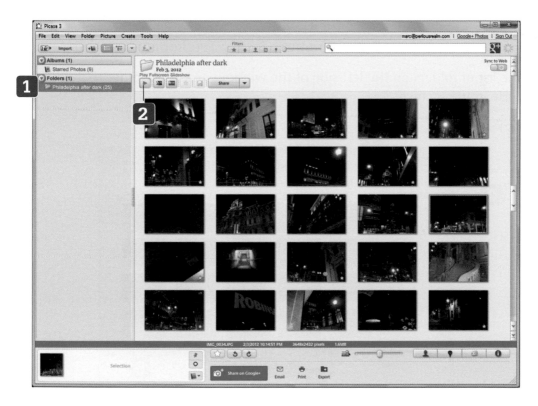

 HOT TIP: To view only those photos that you marked as your favourite, choose the Starred Photos item under Albums.

 SEE ALSO: For information on creating a custom slideshow, see Chapter 10.

Archive your photos

Once you have accumulated a large number of photos, you should think about making an *archive,* which is a kind of long-term backup. Creating an archive is as easy as burning the photos to a CD or DVD. How often you archive depends on how many photos you take and how secure your regular backups are. You may choose to archive a certain number of times per year, be it four, six or more. Or you may want to create archives by the holiday or occasion. However you choose to do it, the important thing is to do it regularly.

1 Insert a blank, writable CD or DVD in your computer's disc tray.

2 In Picasa, choose Tools > Back Up Pictures from the main menu.

3 Choose your Archive backup set from the Backup Set drop-down menu.

4 In the list of folders on the left side of the window, tick each folder that you want to include in the archive.

5 Click Burn.

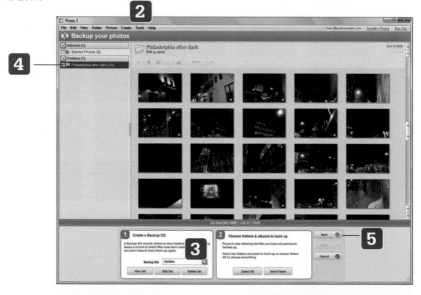

HOT TIP: Once you have archived your photos, you can delete them from your computer if you need to free up some space, but do try to keep the files if space is not a concern. No computer crash survivor has ever regretted backing up too much.

HOT TIP: To include all the folders in the archive, click Select All.

6 Organise your photos

Introduction

Roughly half the people in any house or flat believe that organisational activity, no matter how small, is not merely futile but also self-defeating. Maybe you hold this view, and if so, I am under no illusion that my words will convince you otherwise, so please skip ahead to Chapter 7. But if you choose to work through this chapter, you'll learn how a little routine categorising and compartmentalising can tame even the largest photo library.

View the contents of a folder all at once

Picasa's Library view represents the contents of a folder as a series of *thumbnails* or small versions of the photos inside the folder. (If you like, you can change the size of the thumbnails and make other adjustments to Library view using the commands under the View menu.) Library view is helpful for seeing exactly what you have in your photo library and where particular photos can be found.

1 In Picasa, choose View > Library View if you are not already in Library view.

2 Find the list of folders on the left side of the window. If necessary, expand this list by clicking the triangle icon to the left of where it says Folders.

3 Click a folder to view the photos that it contains.

4 To change the size of the thumbnails, drag the size slider.

5 To magnify part of a thumbnail, drag the Magnify tool from its position to the left of the size slider and hold this tool anywhere over the thumbnail.

6 Display only those photos of a specific type by clicking the buttons under Filters.

7 Drag the Filter By Date Range slider to show only those photos that fall within a particular range of dates; the further you drag the slider to the right, the narrower this range becomes.

 HOT TIP: Choosing View > Small Thumbnails from the menu is the equivalent of moving the size slider all the way to the left, while choosing View > Normal Thumbnails is like positioning the slider in the middle.

? DID YOU KNOW?
You can apply more than one filter simultaneously. Moreover, any filter that you set for the current folder applies to all your folders until you turn the filter off.

View the contents of a folder one photo at a time

By default, Picasa's Edit view displays a single photo at a time. You use this view primarily for editing your photos, but it's also good for showing the details that are too small for the thumbnail images in Library view. And even though you concentrate on a single photo in Edit view, you can step through the rest of the photos in the same folder without going back to Library view.

1 In Picasa's Library view, double-click any photo image.

2 To mark this photo as a favourite, click the Add/Remove star button.

3 To rotate this photo, click either of the Rotate buttons.

4 To change the size of the photo, do any of the following:

 a Click the Fit Photo Inside Viewing Area button to see the entire photo.

 b Click the Display Photo At Actual Size button to see the photo at its full dimensions.

 c Drag the size slider.

HOT TIP: When the dimensions of the photo are larger than the dimensions of the viewing area, you can change which portion of the photo you see by dragging the photo around the viewing area.

5 To view another photo in the folder, do any of the following:

 a Click the Previous button to view the previous photo in the folder.

 b Click any of the thumbnails between the Next and Previous buttons to view the corresponding photo.

 c Click the Next button to view the next photo in the folder.

6 To go back to Library view, click the Back to Library button.

SEE ALSO: Edit view can show two photos instead of just one. See 'View two photos side by side' below for details.

View two photos side by side

Picasa's Edit view can also display two photos side by side (or the same photo twice). Use this feature to help you choose a favourite between two very similar shots. Dual-photo view is even more helpful when you get round to image processing, as you will in the next chapter, since you can compare at a glance the original photo with your edited version, just like the before and after shots in the dodgier sorts of commercial advertising.

1 In Picasa's Edit view, do one of the following:

 a Click the View Two Different Images button to view two different photos.

 b Click the View The Same Image Twice button to view before and after versions of the same photo.

 c Click the View Only One Image button to return to single-photo view.

2 To select one of the two photos, click the desired photo, or click the Switch Which Image Has Focus button.

3 To change the currently selected photo, do any of the following:

 a Click the Previous button to switch to the previous photo in the folder.

 b Click any of the thumbnails between the Next and Previous buttons to switch to the corresponding photo.

 c Click the Next button to switch to the next photo in the folder.

HOT TIP: Choosing two different photos automatically switches to View Two Different Images mode, even if you started out in View the Same Image Twice mode.

4 To alternate between side-by-side and one-above-the-other layouts, click the Switch Between Horizontal and Vertical Layout button.

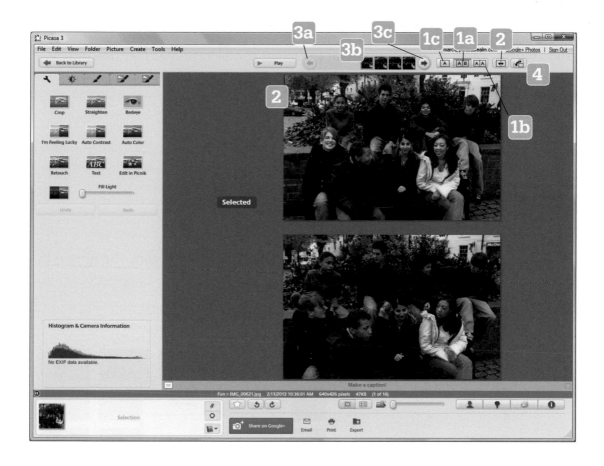

SEE ALSO: Is the photo that you want to compare in a different folder? Simply create an album, add both photos to it and launch Edit view from either photo in it. See 'Create an album' towards the end of this chapter for more information.

Change the properties of a folder

The properties of a folder include its name and date, its location (or, more specifically, the location where you took the pictures that the folder contains) and its text description. If you created the folder within Picasa, you set some of these properties when you created the folder. For folders that you created outside Picasa, or for folders whose properties you wish to change, simply pop open the Folder Properties dialogue box.

1 In the list of folders on the left side of Picasa's Library view, double-click the folder whose properties you want to change.

2 Type a name for the folder in the Name field.

3 Set the date of the folder in the Date field.

4 In the Place taken field, type the name of the place where you took the photos in this folder.

5 In the Description field, type a brief description for the folder.

6 Click OK.

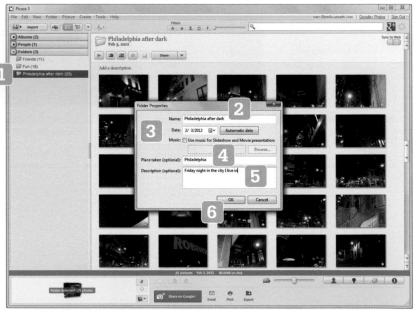

HOT TIP: Click Automatic date to set the date of the folder to match the date of the earliest photo inside it.

Move a photo into a different folder

No matter how scandalous your photo library, the folders themselves aren't in any kind of lockdown. You can move your photos into whichever folders you choose. You can even create new photo folders without leaving Picasa.

1 In Picasa's Library view, open the folder that contains the photo that you want to move.

2 Select this photo.

3 If the destination folder already exists, drag the selected photo directly to this folder or its item in the Folders list.

4 If the destination folder doesn't exist yet, choose File > Move to New Folder from the main menu and specify the properties for this new folder.

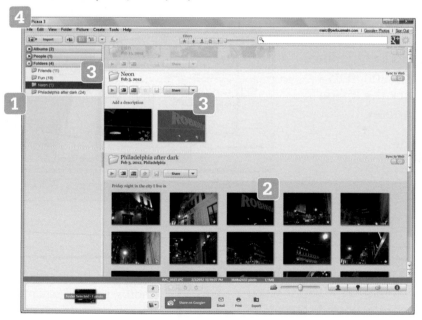

HOT TIP: Select more than one photo by holding down CTRL (Windows) or CMD (Mac) as you click the photos with the mouse.

DID YOU KNOW?
You can also drag a photo to a different place within its current folder.

Rename a photo

Your digital camera assigns a file name to each photo that it takes and these file names come along when you transfer the photos to your computer. The file name of a digital photo is usually a generic abbreviation like *IMG* for image and then a sequential number, such as *IMG_00212.* This system isn't terribly poetic, but it does help to prevent more than one photo in the same folder from having the same file name. If you wish to rename your photos to something more descriptive, you're free to do so – just remember that every photo inside a folder must have a different name.

1 In Picasa's Library view, select the photo that you wish to rename.

2 Choose File > Rename from the main menu.

3 Type the new file name in the field.

4 If you wish to include the date of the photo in its file name, tick the Date option.

5 If you wish to include the photo's resolution in its file name, tick the Image resolution option.

6 Click Rename.

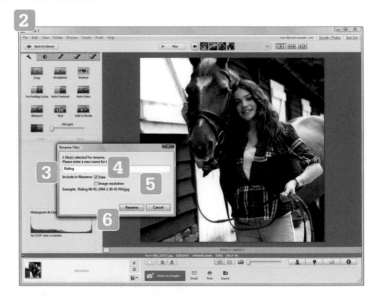

SEE ALSO: The file name of a photo is not as important as the tags that you use to describe the photo's content. See 'Tag a photo' later in this chapter for more information.

HOT TIP: If you select multiple photos, you can rename them all at the same time. Each photo after the first gets the base file name plus a sequential number.

WHAT DOES THIS MEAN?

Resolution: This (in *dpi* or dots per inch) measures the amount of visual information in an image relative to its physical dimensions.

Add a caption to a photo

Your digital photos have built-in fields, which is to say slots or blanks, for *metadata*. Metadata are simply extraneous pieces of information attached to the file that describe the file's contents. Many of these metadata are technical in nature, but some, such as the caption field, are of use to people. Any caption that you place inside this field becomes part of the photo's metadata. When you transfer the image file to the Web or burn it to a DVD, all the metadata – including the caption – come along for the ride.

1 In Picasa's Library view, double-click the photo that you want to caption.

2 If you do not see the *Make A Caption!* legend or the photo's current caption, click the Show/Hide Caption button.

3 Click the *Make A Caption!* legend or the current caption.

4 To erase the current caption (if any), click the Delete This Caption button.

5 Type the caption for the photo and press Enter or Return.

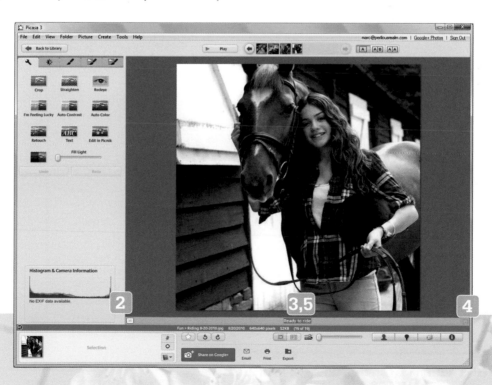

WHAT DOES THIS MEAN?
Metadata: These are additional descriptors associated with a particular computer file.

Tag a photo

Tags are words or short phrases that describe the subject of the photo, the location, the situation, the people in the background and so on. Like the caption, tags are part of the photo's metadata, so they follow the photo wherever it goes. Tags are most useful for searching. A photo's file name is usually not descriptive, and the folder in which you store the photo is too easy to change. Moreover, your computer is not yet sophisticated enough to scan the image itself and understand what or who it's looking at, at least not as reliably as you can. So by adding tags to the metadata, you're essentially providing a search-function cheat sheet. When the search is for *Mary* or *Piccadilly Circus*, for example, photos with these particular tags appear in the results.

1 In Picasa's Library view, double-click the photo that you want to tag.

2 Click the Show/Hide Tags Panel button.

3 Type tags to add to the photo, pressing Enter or Return after each one.

4 To remove a tag from the photo, hover over the tag with the mouse pointer and click its Remove icon.

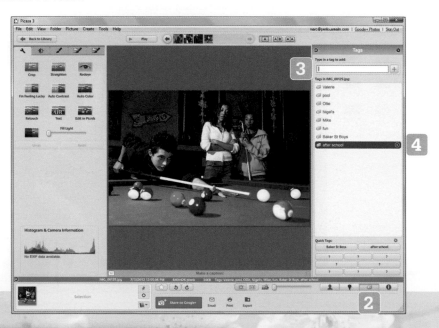

HOT TIP: Tags can be a single word or a phrase, but in general, the shorter they are, the more useful they are. As for the wording of the tags, try to pick terms that you would use if you were searching for the photo.

DID YOU KNOW?
Folders and albums automatically acquire all the tags of the photos inside them.

Use Quick Tags

Picasa's Quick Tags feature makes it easy for you to apply common tags to your photos. When you're looking at a couple of hundred photos of the *Pyramid of Giza* or *Jason's graduation party*, the judicious use of Quick Tags can make your tagging session go faster.

1. In Picasa, while tagging a photo, click the Configure Quick Tags button.

2. Type commonly used tags in the fields.

3. If you want Picasa to fill empty fields with tags that you use frequently, click the Autofill button.

4. If you want to save the top two fields for your most recent tags, whatever they happen to be, tick the Reserve option; otherwise, untick this option for two more Quick Tags.

5. Click OK.

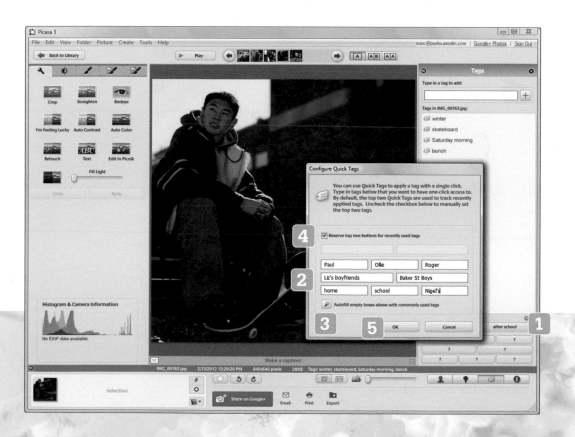

6 To add a tag to a photo using the Quick Tag controls, view the photo and click the corresponding Quick Tag button.

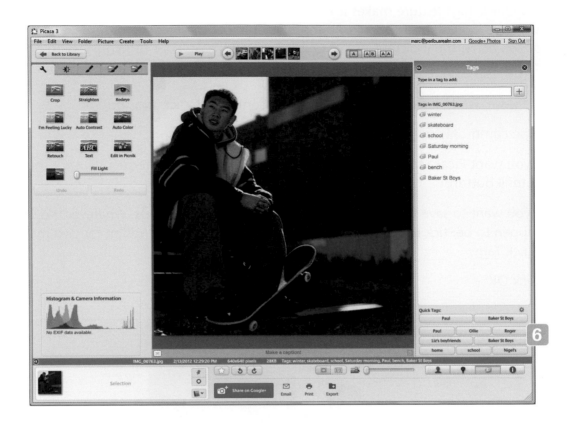

HOT TIP: Notice that some fields are larger than others; reserve these for longer tags.

Identify the people in your photos

Picasa provides a way for you to pick out the people in your photos and associate them with their names, nicknames and email addresses. Once you've identified someone, Picasa may be able to recognise this person automatically the next time you import photos.

1 In Picasa's Library view, double-click a photo with people to define.

2 Click the Show/Hide People Panel button.

3 For any person that Picasa thinks it recognises, click the tick button to confirm this person's identity, or click the cancel button if Picasa hasn't guessed correctly.

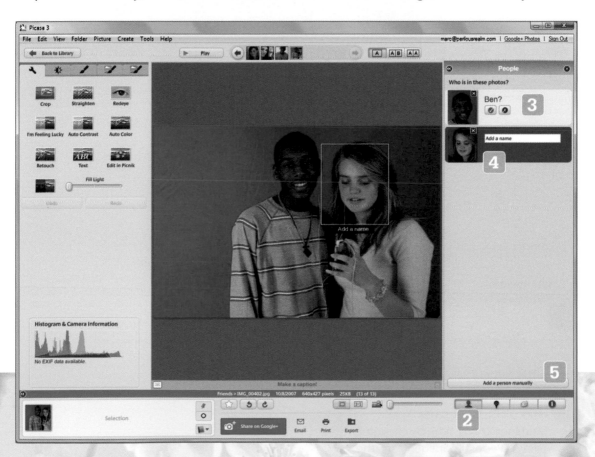

4 For any person that Picasa detects but doesn't recognise, type the person's name and press Enter or Return, or click the X icon to ignore this person.

5 For any person that Picasa doesn't detect, click the Add a person manually button and follow the onscreen instructions.

6 After Step 4 or Step 5, the People Manager appears. If the identified person isn't already in the People list, click New Person, fill out his or her information and click OK; otherwise, make sure the correct person is selected in the People list and click Choose.

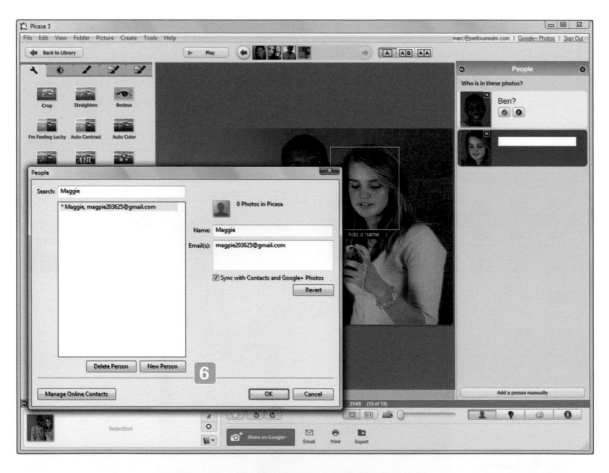

HOT TIP: Call up the People Manager at any time by choosing Tools > People Manager from the main menu.

Identify the places in your photos

Picasa enables you to indicate exactly where you took each of your photos. This feature isn't just for helping you to remember where you were last night; the software connects to Google Maps and it can use your *geotags*, as these locators are called, to display your photos at their precise coordinates.

1 In Picasa's Library view, select a photo.

2 Click the Show/Hide Places Panel button.

3 In the Search field, type the location where you took the photo. You can use a street address, the name of the town, the name of the destination, the postcode, a landmark and so on, but try to be as precise as possible.

4 Click the Search button.

5 Click OK in the Put photo here? box.

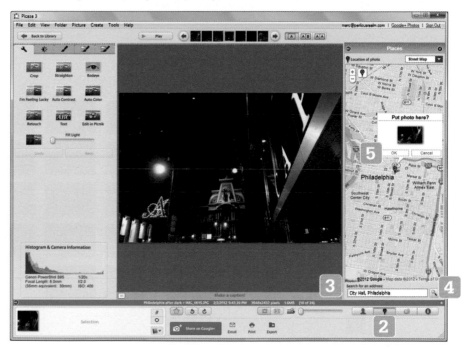

? DID YOU KNOW?
If your camera has a built-in GPS, your photos may already be geotagged.

🔥 HOT TIP: Chart your journeys by downloading and installing Google Earth at www.google.com/earth/index.html. Google Earth can display your photos in 3D space according to the geotags that you have defined for them.

Create an album

An *album* in Picasa is a collection of photos. You may add photos to the album from any folder in Picasa, and any given photo can belong to any number of albums. Adding a photo to an album doesn't change the physical location of the photo; the photo remains in its current folder. Likewise, removing a photo from an album doesn't delete the photo file but simply excludes the photo from that particular grouping. Use albums to gather and organise photos of a particular subject or type from across your photo library.

1 In Picasa's Library view, click the Create a New Album button.

2 Type a name for the album in the Name field and set a date for the album in the Date field.

3 If applicable, in the Place taken field, type the location where you took the photos.

4 Type a description for the album in the Description field.

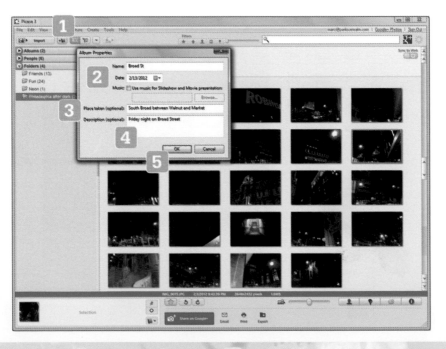

HOT TIP: To change the properties of an album, double-click its name in the Albums list.

5 Click OK.

6 To add photos to the album, drag them from Library view and drop them on the album's name in the Albums list.

7 To view the contents of the album, click its name in the Albums list.

8 To remove a photo from the album, click the photo image and then choose File > Remove from Album from the main menu.

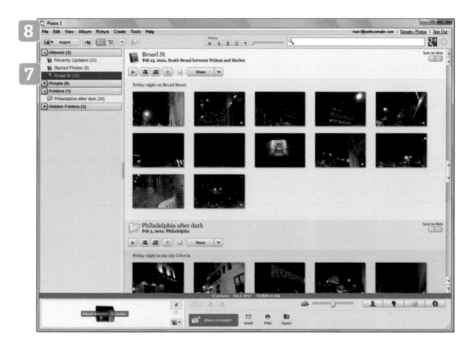

Search for photos

Once you've amassed a sizable photo library, Picasa's search feature becomes an invaluable tool for finding the photos that you've been so diligent about cataloguing. Enter a search term and Picasa returns all the photos with matching file names, folder names, album names and tags.

1 If necessary, switch to Library view.

2 Type a search term in the search field and press Enter or Return.

3 To clear your search, click the X button on the right side of the search field.

4 To return to general Library view, click Back to View All.

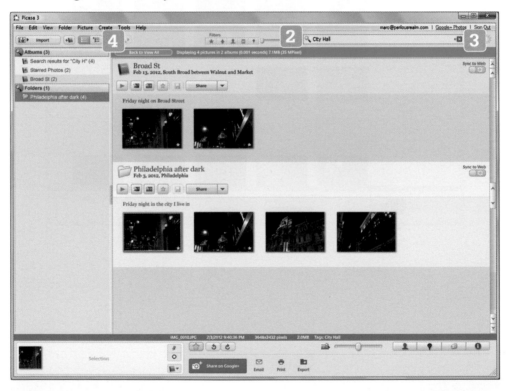

HOT TIP: Picasa filters the list of albums, people and folders on the left side of the window according to the results of the search.

7 Process the image

Introduction

Whatever the merits of film might be, it simply can't compete with the sheer scope and variety of post-camera processing in digital photography. What used to take a darkroom, a photo lab and an arsenal of expensive equipment now requires an average home computer and some free software. In this chapter, I show you how to use Picasa to adjust common technical characteristics of your digital photos, including exposure, white balance and colour temperature.

Adjust exposure automatically

Picasa's Auto Contrast feature analyses the exposure in a photo and makes adjustments based on the findings. Auto Contrast doesn't always guess the ideal exposure for your particular shot, so it doesn't work miracles, but it can help to nudge very poorly lit shots in the right direction.

1 In Picasa's Library view, double-click a photo.

2 If necessary, switch to the Commonly Needed Fixes tab.

3 Click the Auto Contrast button.

4 Click Back to Library to return to Library view.

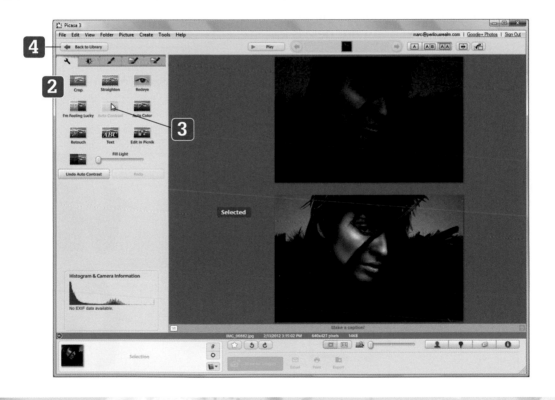

HOT TIP: You can achieve the same effect by clicking the One-Click Fix For Lighting button under the Finely Tuned Lighting and Color Fixes tab.

Adjust exposure manually

Manual exposure is trickier to master than Auto Contrast, but the results are almost always superior, especially when the exposure in the photo is close to what you want. This process deals with three ranges of exposure, shadows, fill light and highlights, which correspond with the dark parts, the midtones and the bright parts of the image. The best approach is to adjust the fill light and one of the extremes, but feel free to experiment to get the look you desire.

1 In Picasa's Library view, double-click a photo.

2 If necessary, switch to the Finely Tuned Lighting and Color Fixes tab.

3 Drag the Fill Light slider to boost the grey tones in the image and bring out details lost in shadows.

? DID YOU KNOW?

When brightness conceals detail, the photo has flared highlights; when darkness conceals detail, the photo has crushed blacks.

4 Drag the Highlights slider to boost the white tones in the image, making the bright parts brighter.

5 Drag the Shadows slider to boost the black tones in the image, making the dark parts darker.

6 Click Back to Library to return to Library view.

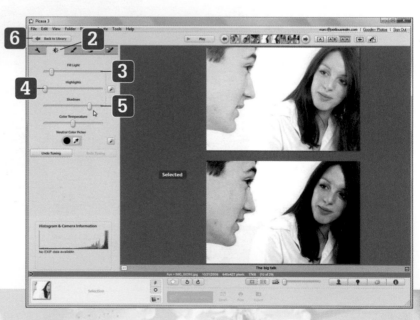

HOT TIP: As you adjust the exposure, keep your eye on the histogram at the bottom of the tab. This graph displays the distribution of tones in the image from black to white.

Adjust white balance automatically

Auto Color in Picasa can remove unwanted colour casts from a photo. This feature works best when the white balance is obviously skewed, but you may be surprised at how well it handles subtleties, especially when you compare it with Auto Contrast. Make Auto Color your first stop for fixing white balance, then move on to manual adjustment if necessary.

1 In Picasa's Library view, double-click a photo.

2 If necessary, switch to the Commonly Needed Fixes tab.

3 Click the Auto Color button.

4 Click Back to Library to return to Library view.

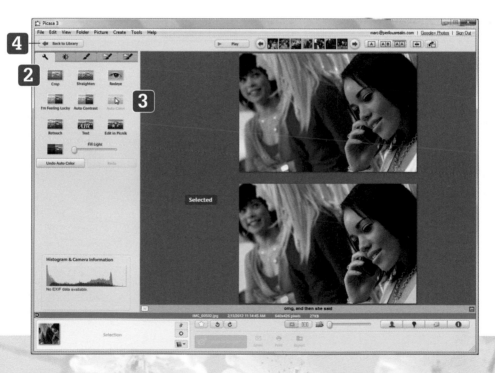

HOT TIP: The One-Click Fix For Color button under the Finely Tuned Lighting and Color Fixes tab has the same function.

Adjust white balance manually

Manual white balance gives you more control over the exact level of colour correction in a photo, but for it to work properly there needs to be some neutral grey or white in the image. (You may be able to substitute black.) Picasa shifts the tones of the photo around the grey or white that you pick out.

1 In Picasa's Library view, double-click a photo.

2 If necessary, switch to the Finely Tuned Lighting and Color Fixes tab.

3 Click the eyedropper icon under Neutral Color Picker.

4 Move the mouse pointer onto the image and click an area that is neutral grey or white.

5 Click Back to Library to return to Library view.

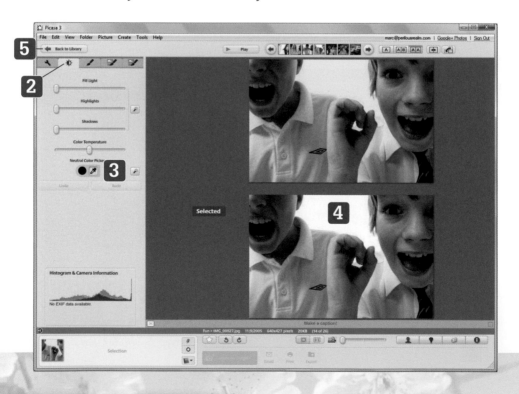

HOT TIP: Drag the mouse pointer across the image to compare white balance corrections from different regions.

Adjust the colour temperature

The *colour temperature* of a photo indicates the warmth or coolness of its colours. Picasa enables you to shift the colours one way or another, which can affect the mood or the perceived emotions of the shot. It can also help you to compensate for too much warmth or too much coolness in the photo.

1 In Picasa's Library view, double-click a photo.

2 If necessary, switch to the Finely Tuned Lighting and Color Fixes tab.

3 Drag the Color Temperature slider to the left to shift the colour temperature towards cooler colours, or drag the slider to the right to shift the colour temperature towards warmer colours.

4 Click Back to Library to return to Library view.

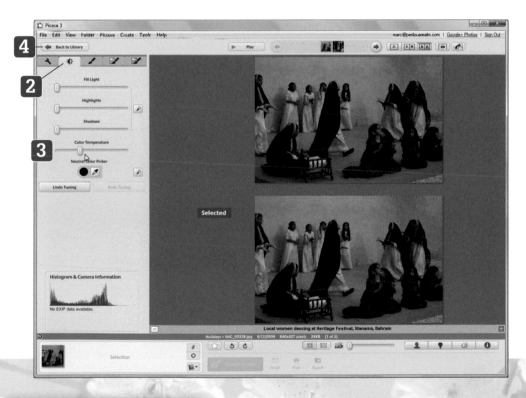

? DID YOU KNOW?
Cooler colours are actually higher on the temperature scale, while warmer colours are lower.

Adjust saturation

The *saturation* of a photo describes the vividness of its colour. Increasing saturation can enliven a drab shot, while decreasing saturation can reduce the impact of brightly coloured distractions in the frame. You might also play with the saturation for purely creative effect.

1 In Picasa's Library view, double-click a photo.

2 If necessary, switch to the Fun and Useful Image Processing tab.

3 Click Saturation.

4 Drag the Amount slider to the left to wash out the colours, or drag the slider to the right to intensify the colours.

5 Click Apply.

6 Click Back to Library to return to Library view.

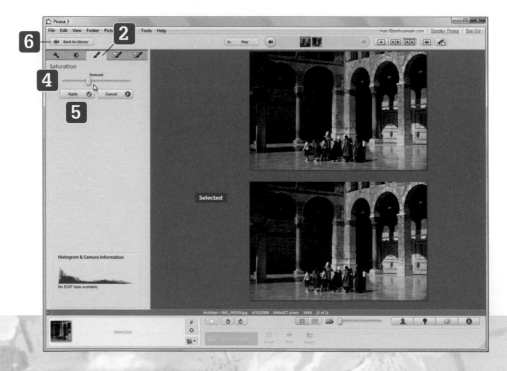

HOT TIP: Lowering saturation can help to bring out detail in regions of vivid colour.

Rotate the image

Sometimes your computer displays your photos the wrong way around. You get *landscape*, or sideways, orientation when you ought to get *portrait*, and vice versa. When this happens, you can simply rotate the photo in Picasa so that it's showing the right way up.

1 In Picasa's Library view, double-click the image that you want to rotate.

2 Click the Rotate Counter-clockwise button to rotate the image 90 degrees anticlockwise.

3 Click the Rotate Clockwise button to rotate the image 90 degrees clockwise.

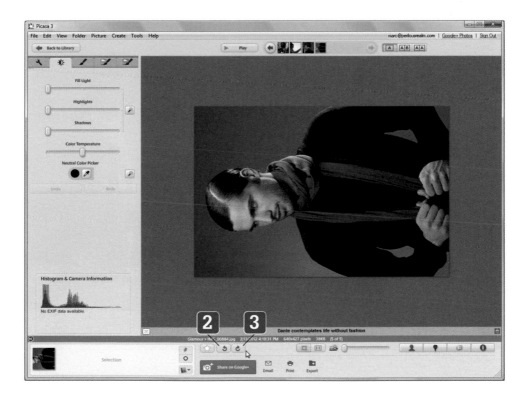

 HOT TIP: You can also rotate a photo by rotating its thumbnail in Library view. Look for the Rotate buttons towards the bottom of the interface, in the same location as in Edit view.

WHAT DOES THIS MEAN?

Orientation: A photo in landscape orientation is wider than it is tall, whereas a photo in portrait orientation is taller than it is wide.

Straighten the image

When the horizon line of your photo comes out on an unintentional skew, you can tilt the image slightly one way or the other in Picasa.

1 From the Commonly Needed Fixes tab in Edit view, click the Straighten button.

2 Drag the slider to the left or right to rotate the photo clockwise or anticlockwise.

3 Click Apply.

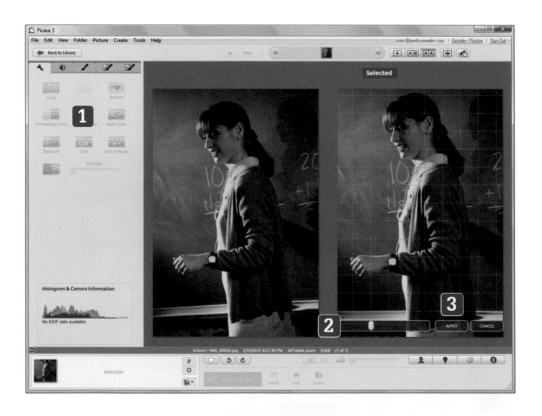

HOT TIP: For best results, try to line up a horizontal or vertical line in the photo with the grid that appears across the photo.

ALERT: Straightening the image may come at the cost of some sharpness.

Crop the image

Cropping your photo means to trim its edges to get it to fit a certain set of dimensions. This technique is crucial for sizing your photos before you make prints. If you supply uncropped photos, many print services will simply crop them for you with the level of care that you would expect from a faceless, cost-obsessed corporation. Save yourself the frustration of poorly cropped prints by making your own cropping decisions.

1 From the Commonly Needed Fixes tab in Edit view, click the Crop button.

2 Choose the desired dimensions or aspect ratio from the drop-down menu.

3 Move the mouse pointer onto your photo and drag the mouse to create a crop area of your chosen aspect ratio.

4 Release the mouse button.

5 Position the crop area by dragging it, or drag the corners of the crop area to resize it.

6 To rotate the crop area, click Rotate.

7 To preview the cropped photo, click Preview. Picasa automatically reverts to the original photo after a second or two.

8 To start again, click Reset.

9 Click Apply.

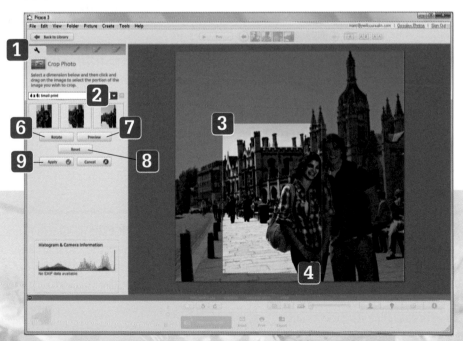

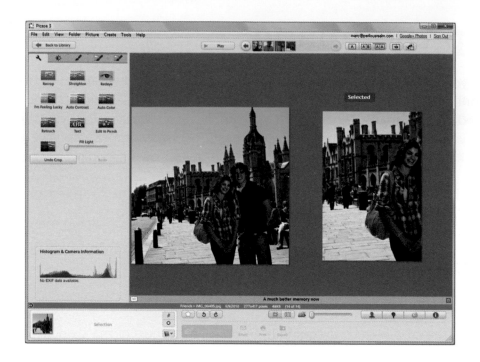

HOT TIP: For any given aspect ratio, Picasa automatically suggests three crop areas, which appear as the three thumbnail images directly below the drop-down menu. To apply one of these crop areas, click its thumbnail.

HOT TIP: Change the aspect ratio of the crop area by choosing a different option from the drop-down menu.

Remove red-eye

You'll recall from Chapter 2 that *red-eye* is the result of unintentionally photographing your subject's retina. If red-eye gets past your camera's red-eye reduction system, you can correct it in Picasa.

1 From the Basic Fixes tab in Edit view, click the Redeye button.

2 Position the mouse pointer over an eye with red-eye.

3 Hold down the mouse button and drag a rectangle around the eye. For best results, keep the rectangle tight.

4 When you've finished, click Apply.

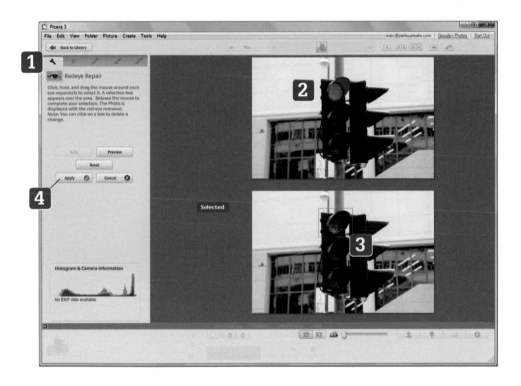

114

Touch up the image

Many photos benefit from a little *retouching*, which is the process of erasing and repairing parts of the image. Retouching can be relatively simple, such as patching over an insect that flew into frame, or it can be complex, such as eliminating an ex-boyfriend from the photographic record. Advanced retouching requires skill and experience to pull off, but simple fixes are quite easy to perform.

1 From the Commonly Needed Fixes tab in Edit view, click the Retouch button.

2 Set the size of the brush by dragging the Brush Size slider.

3 Position the brush over the area that you want to retouch and click the mouse button.

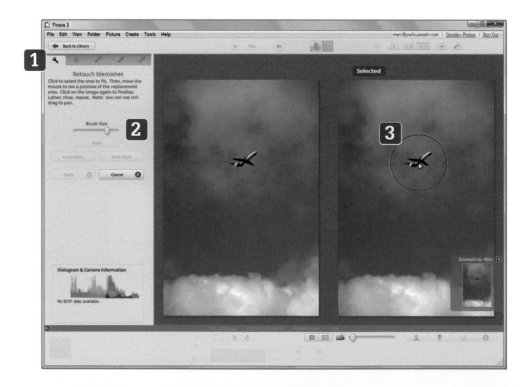

SEE ALSO: 'Remove blemishes in Google+' in Chapter 9 gives details on retouching skin imperfections.

HOT TIP: For best results, try to choose a patch region with similar colour, texture and lighting.

4 Move the brush to the area of the image that you want to use as the patch.

5 When you've found a good patch, click the mouse button.

6 Repeat Steps 4 and 5 as required.

7 Click Apply.

Sharpen the image

Sharpening helps the contours of objects to stand out against the background. It doesn't correct the focus of the shot per se, but it can add some extra definition in shots where the focus is slightly soft.

1 In Picasa's Library view, double-click a photo.

2 If necessary, switch to the Fun and Useful Image Processing tab.

3 Click Sharpen.

4 Drag the Amount slider to the right to increase sharpening.

5 Click Apply.

6 Click Back to Library to return to Library view.

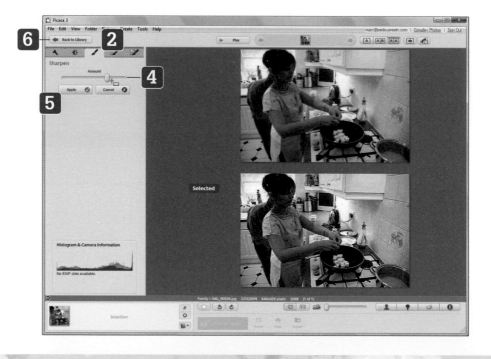

 HOT TIP: If you make an image smaller, as you will in Chapter 9, always sharpen the smaller version.

 HOT TIP: RAW format provides minimal (if any) in-camera sharpening, so if you shoot in RAW, you will probably find sharpening quite useful.

Blur the background

Picasa's Soft Focus feature enables you to target a region of the photo for hard focus and then soften the focus of everything outside the region. This feature is most useful for isolating the foreground from the background. But remember, setting your camera for a low depth of field does the same thing and it usually gives you better results.

1 In Picasa's Library view, double-click a photo.

2 If necessary, switch to the Fun and Useful Image Processing tab.

3 Click Soft Focus.

4 Drag the crosshairs on the photo to position the centre of focus.

5 Drag the Size slider to adjust the size of the focus zone.

6 Drag the Amount slider to adjust the amount of focus outside the focus zone.

7 Click Apply.

8 Click Back to Library to return to Library view.

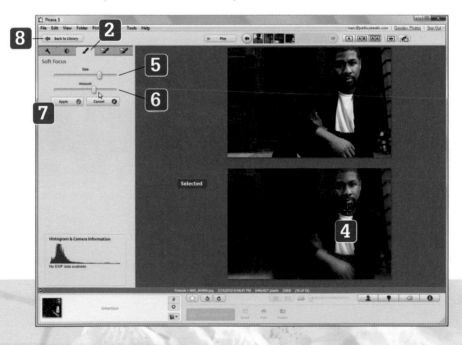

HOT TIP: To soften the entire image, drag the Size slider all the way to the left.

Add text to the image

You might choose to place some text directly on top of a photo. This isn't the same as attaching a caption to the photo by way of metadata, since in this case the text becomes part of the image itself. While you can certainly add text that works like a caption, it's more common to use this technique to suggest lines of dialogue for the people in the photos or to make barely comprehensible statements about the acquisition of cheeseburgers.

1 From the Commonly Needed Fixes tab in Edit view, click the Text button.

2 Click anywhere on the image and type some text. Press Enter or Return to start a new line.

HOT TIP: To use the photo's caption as the text, click the Copy Caption button.

3 Choose the font, size, style and alignment of the text using the first group of controls under the Commonly Needed Fixes tab.

4 Choose the interior colour of the text, the outline colour of the text and the width of the outline using the second group of controls.

5 To make the text appear transparent, drag the Transparency slider to the left.

6 To move the text, drag its border.

7 To rotate the text, hover over the text frame and drag the rotate control that appears.

8 Click Apply.

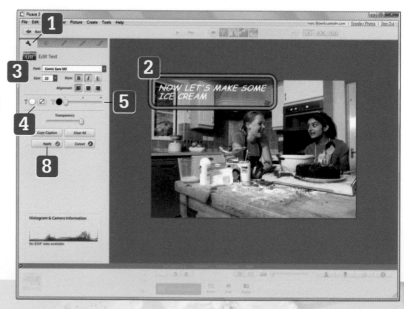

 DID YOU KNOW?

If you didn't catch the cheeseburger reference, visit http://icanhascheezburger.com, just once, just to say that you were there.

HOT TIP: For different text formatting in the same image, add multiple text objects.

Convert the photo to black and white or sepia

While you can shoot in black and white or sepia in most digital cameras, you needn't limit your options. Shoot in colour as usual and then convert the photo to black and white or sepia in Picasa. Not only do you get better results in general and more editing options, you also preserve the full-colour versions of your shots for future projects.

1 In Picasa's Library view, double-click a photo.

2 If necessary, switch to the Fun and Useful Image Processing tab.

3 To convert the photo to black and white, click the B&W button.

4 To convert the photo to sepia, click the Sepia button.

5 Click Back to Library to return to Library view.

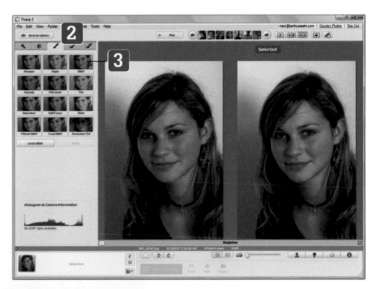

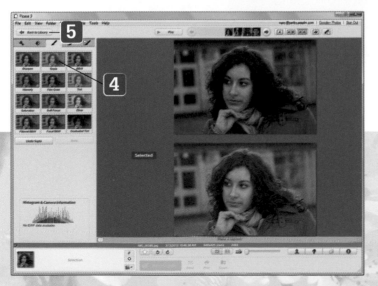

HOT TIP: The Filtered B&W effect gives you more authentic-looking results, while the Focal B&W effect gradually fades from colour to greyscale.

Tint the image

When it comes to colour modification in digital photography, why limit yourself to black and white or brown and white? Using Picasa's Tint feature, you can work with blue and white, green and white, red and white, or any-conceivable-colour and white. Moreover, tinting a photo whose subject appears against a solid background can dramatically change the colour content of the image for creative effect.

1 In Picasa's Library view, double-click a photo.

2 If necessary, switch to the Fun and Useful Image Processing tab.

3 Click Tint.

4 Click the Pick Color box and choose the colour to use as the tint.

5 Drag the Fade slider to the right to mix in the original colours of the image.

6 Click Apply.

7 Click Back to Library to return to Library view.

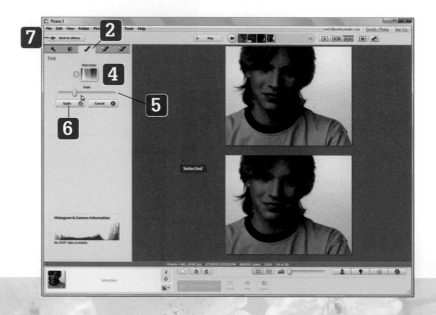

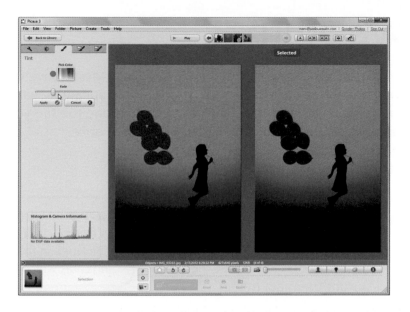

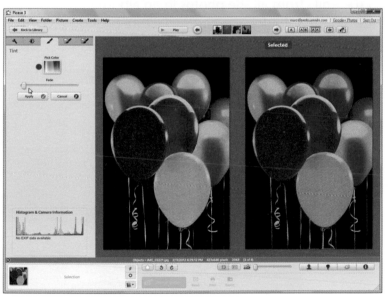

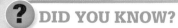

Remove edits

One of the nicest aspects of Picasa is that it provides a non-destructive editing environment, which means that you can edit your photos repeatedly without risking the original image files. If you ever decide that you have gone too far, you can roll back your changes one by one, or you can get rid of them all at once.

1 From Picasa's Library view, double-click a photo.

2 To remove one edit at a time, click the Undo button. You can find this button under whichever tab you prefer to use.

3 To remove all the edits at once, choose Picture > Undo All Edits from the main menu.

> **HOT TIP:** Effects are removed in reverse chronological order. The label on the Undo button indicates which effect is next.

4 To remove all the edits from all the photos in an album or folder, return to Library view, select the album or folder and choose Picture > Undo All Edits from the main menu.

> **HOT TIP:** The Redo button reapplies the most recent change that you made.

> **DID YOU KNOW?** You can use the Undo All Edits menu command to remove all the edits in a set of search results.

Save edits

Picasa's non-destructive editing environment eliminates the need for you to save your edited versions, as long as you always use Picasa to edit your photos. If you want to work with an edited photo in other software, you should save the edited version as an image file. Even after you save, Picasa keeps a backup of the original photo to preserve your non-destructive editing options.

1 In Picasa's Library view, select the photo that you want to save.

2 To save this photo under its current file name, click the Save edited photos to disk button, or choose File > Save from the main menu.

3 To save this photo under a different file name, choose File > Save As from the main menu.

4 To save this photo under its current file name with a sequential number, choose File > Save A Copy from the main menu.

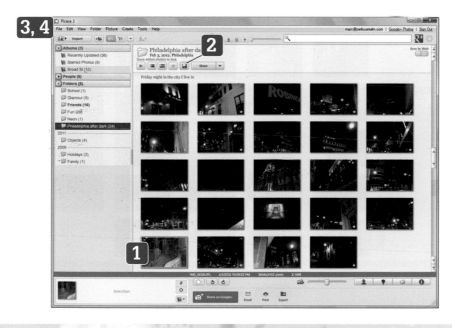

HOT TIP: Hold down CTRL (Windows) or CMD (Mac) to select multiple photos.

SEE ALSO: If you want to resize the image or adjust image quality when you save, use the Export command – see Chapter 10 for details.

Revert to the original image

After you have saved the edited version of a photo, you can replace it with the original version in Picasa. This feature gives you extra protection against losing the version of the photo that came out of your camera.

1 In Picasa's Library view, select the photo that you want to revert to its original version.

2 Choose File > Revert from the main menu.

3 To revert to the original version of the photo and lose all edits permanently, click Revert.

4 To undo the last save and preserve all prior edits, click Undo Save.

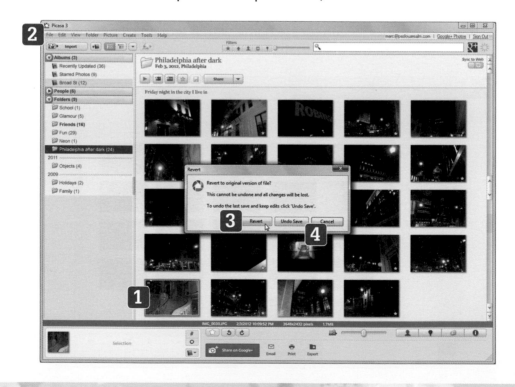

HOT TIP: You can't revert files that you saved with the Save As or Save A Copy commands, but then again, you don't need to.

HOT TIP: Don't tick the Do Not Ask Me Again option, since you want to keep the flexibility to revert or undo.

8 Share your photos on Google+

Introduction

Social media provide the platform for all sorts of meaningful (and meaningless) exchanges, and they're particularly well suited for sharing your photos with the people who matter. In this chapter, I show you how to use Google+ to broadcast your photos far and wide.

Sign up for Google+

The Google+ social network gives you an easy way to share your photos online. Every account comes with one gigabyte of free storage space for your print-quality photos (and unlimited free storage space for Web-quality photos), which you organise into one or more *albums*. These online collections correspond to the albums and folders that you create on your computer with Picasa. To share your Google+ albums, you can make them visible to everyone on the Web, you can restrict them to the members of your social circle, or you can send a link to select people by email.

1 Close Picasa if it is open.

2 Launch your Web browser and point it to http://plus.google.com/

3 If you don't have a Google account, click Create an account and follow the onscreen instructions.

4 If you already have a Google account, click Sign in. A new page appears. Type your email address and password and click Sign in.

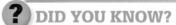

? DID YOU KNOW?
One gigabyte of storage is enough for hundreds of print-quality photos.

🔥 HOT TIP: Tick the Stay signed in option for one-click access to your Google+ albums from Picasa.

🔥 HOT TIP: You can use Google+ to back up your photos until you get round to buying an external hard drive.

Upload photos to Google+

Once you've signed up for Google+, you can upload your photos to the social network directly from Picasa. The software keeps track of which photos you've uploaded from which albums and folders.

1 In Picasa's Library view, click a photo to upload to Google+. If you want to include all the photos in an album or folder, simply click the album or folder.

2 Click the Hold Selected Items button in the tray at the bottom left of the window.

3 Click the Share on Google+ button. If you aren't already signed in, Picasa asks for your login information.

4 Do one of the following:

 a Use the new Google+ album that Picasa automatically creates.

 b Choose an existing Google+ album from the drop-down menu.

 c Click New and type a name for the new Google+ album.

5 From the Image size to upload drop-down menu, choose the appropriate size for the online versions of your photos.

6 In the Add a message field, type an optional message to go with these photos.

7 Click the field beneath the Add a message field to determine which of your Google+ contacts can see these photos.

8 Click the green Share button (if you have selected contacts) or the green Upload button (if you have not).

9 Click Upload in the dialogue box that appears, if necessary.

10 Click View Online to view your newly uploaded photos on Google+.

 HOT TIP: You can also upload photos from your Web browser when you're logged into Google+. Browse to your Photos page and click the Upload New Photos button, or open any Google+ album and click the Add More Photos button.

HOT TIP: To select multiple photos, hold down CTRL (Windows) or CMD (Mac) as you click with the mouse.

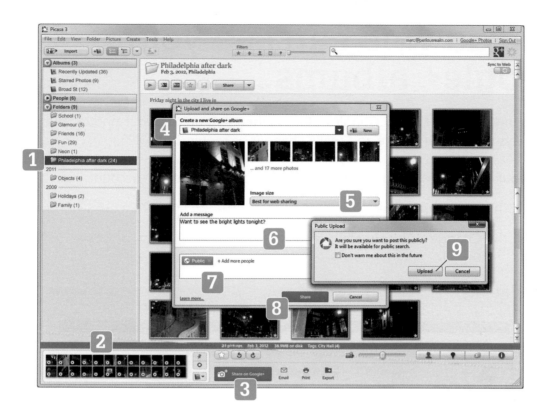

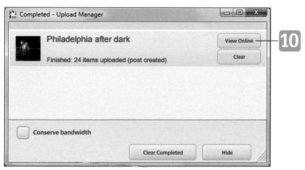

ALERT: Uploading your images at original size counts towards your one gigabyte of free storage space, while uploading your images at Web-optimised size does not.

HOT TIP: Leave the Add circles or people to share with field blank to create a private Google+ album, or one that only you can view.

Decide who can see your Google+ albums

You set the access level for a Google+ album when you upload your photos, but you can always revisit your choice and make changes as required.

1 In your Web browser, go to the Photos page of your Google+ account.

2 Click the Your albums link.

3 Click the Change how your albums are shared link.

▶ **SEE ALSO:** If you want to share your Google+ albums with people who aren't Google+ members, see 'Share your Google+ albums with non-members by email' later in this chapter.

HOT TIP: An easy way to go to your Photos page is to click the Google+ Photos link in the upper right corner of the Picasa interface. This link appears only when you're logged into Google+ from Picasa.

4 For any album in the list, do one of the following:

 a Choose Public to make the album visible to everyone on the Web.

 b Choose Extended circles or Your circles to make the album visible to your Google+ contacts.

 c Choose Limited to make the album visible to your Google+ contacts on a name-by-name basis only.

 d Choose Only you to make the album private.

5 Tick the Hide location info box to prevent visitors from accessing your images' geotags.

6 Tick the box next to the lock icon to prevent your contacts from sharing the album, even if they have permission to view it.

7 Click Save and confirm your changes as required.

8 Click Done.

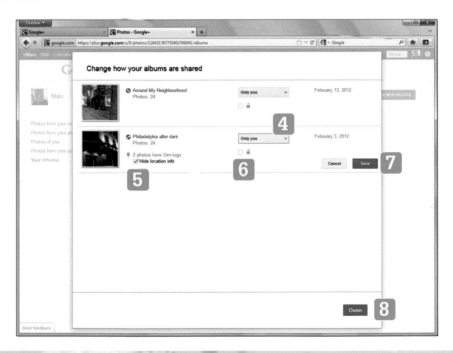

HOT TIP: You can also set the access level for a Google+ album directly in Picasa. Click the Share button for an uploaded folder, add or remove people to share with, and click Upload.

Share your Google+ albums with non-members by email

Once you have uploaded photos to Google+, you can make them accessible to anyone, not just your Google+ contacts. Of course, Google desperately wants you to recruit everyone you have ever known for membership in its social network, but it's your choice.

1 In your Web browser, go to the Photos page of your Google+ account.

2 Click the Your albums link.

3 Click the album that you wish to share.

4 Click Options and choose Share album via link.

5 Copy the Web address that appears in the Share via link field.

6 Launch your email application, open a new message and paste the link into the body text.

7 Address and send the email.

> **! ALERT:** Sharing a private Google+ album in this way changes its access level to Limited.

> **! ALERT:** Once you have given out a link to your album, your recipients can send this link to anyone in the world. The only way to prevent unauthorised visitors from seeing your album is to delete it from Google+.

> **▶ SEE ALSO:** To send your photos without using Google+, see 'Email photos without Google+' in Chapter 10.

Synchronise your Google+ albums

Synchronising a Google+ album means to keep it up to date with the offline version of the album that resides on your computer. When you turn on synchronisation for an album or folder on your computer, Picasa automatically uploads new photos that you add to this collection, and it automatically deletes the photos that you remove.

1. In Picasa, if necessary, click the Sign in with Google account link in the upper right corner of the window and type the email address and password that you use to log in.

2. In Library view, click the album or folder on your computer that corresponds to the Google+ album that you want to synchronise.

3. Click the Sync to Web button.

4. If necessary, click Sync.

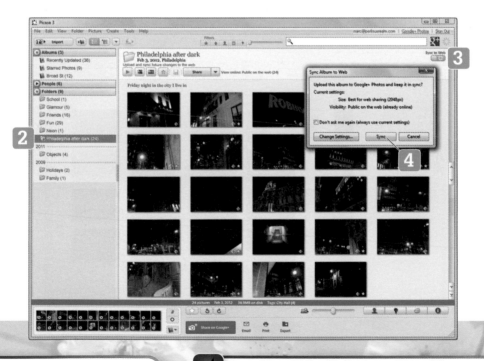

HOT TIP: Turn off synchronisation for this album by clicking the Sync to Web button again.

HOT TIP: To change the default quality setting of your synchronised photos for this album, click the inverted triangle next to the Share button and choose 2048 Max Width for Web-quality photos or Original Size Images for print-quality photos.

Delete a Google+ album using Picasa

You can delete a Google+ album directly within the Picasa environment without going to the trouble of launching your Web browser. Deleting the Google+ album doesn't affect the offline versions of your photos, so you are free to recreate the Google+ album at any time.

1 In Picasa, if necessary, click the Sign in with Google account link in the upper right corner of the window and type the email address and password that you use to log in.

2 In Library view, click the album or folder on your computer that corresponds to the Google+ album that you want to manage.

3 Click the inverted triangle icon next to the Share button.

4 Choose Delete Online Album.

5 Click Delete Album.

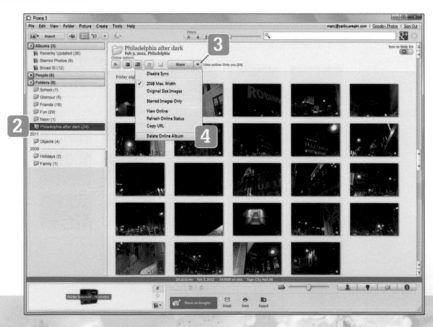

HOT TIP: You can also delete a Google+ album from your Web browser when you're logged into the Google+ network. Open any Google+ album, click Options and choose Delete Album.

Import photos from Google+ to Picasa

Picasa can grab online photos from your Google+ albums and store copies of these photos on your computer. Use this feature for adding albums to your library that you created online or for restoring photos that you lost in a computer crash.

1 In Picasa, if necessary, click the Sign in with Google account link in the upper right corner of the window and type the email address and password that you use to log in.

2 Choose File > Import From Google+ Photos from the main menu.

3 Choose the Import all albums option to import all Google+ albums, or choose the Import selected albums option and then tick the Google+ albums that you want to import.

4 Click OK.

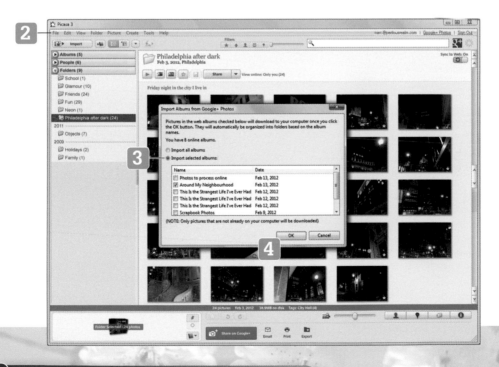

HOT TIP: Picasa doesn't import photos that already exist on your computer, even if the online versions are different from the offline ones. Similarly, Picasa doesn't import edited photos that you saved as new files from the Creative Kit.

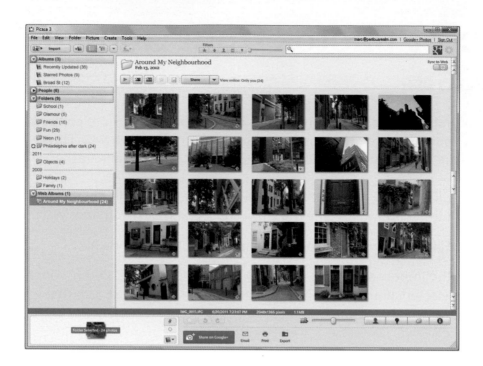

SEE ALSO: To download updated or edited photos, see 'Download photos from Google+' in Chapter 9.

DID YOU KNOW?

Picasa stores your downloaded albums in the Downloaded Albums folder, which you should find in Pictures or My Pictures.

9 Edit the image in Google+

Introduction

Not only does Google+ provide a convenient way to share your digital photos, it also includes a number of fun and powerful image-editing tools. Some of them duplicate features that you find in Picasa, but many others go beyond anything that Picasa has to offer. In this chapter, I show you how to use several of these, but please feel free to experiment with the rest.

Open a photo in Google+

You can probably figure this one out on your own, but just in case, here's how to open a photo that you've uploaded to Google+.

1 In your Web browser, go to the Photos page of your Google+ account.

2 Click the Your albums link.

3 Click the album that contains the photo that you want to open.

4 Click the photo. The site opens this photo for viewing and editing.

5 To show a larger version of the photo, hover over the photo image with the mouse pointer and click the two-way arrow icon that appears in the lower right corner.

6 To step through the photos in the current album, click the navigation icons on the left and right sides of the photo image.

7 To view thumbnails of all the photos in the current album, click the View All link and click any thumbnail to jump to this photo. Click the View All link again to hide the thumbnails.

8 Click the Creative Kit link to access Google+ editing tools.

9 To return to the photo album, click either the name of the photo album next to the View All link or the X icon in the upper right corner.

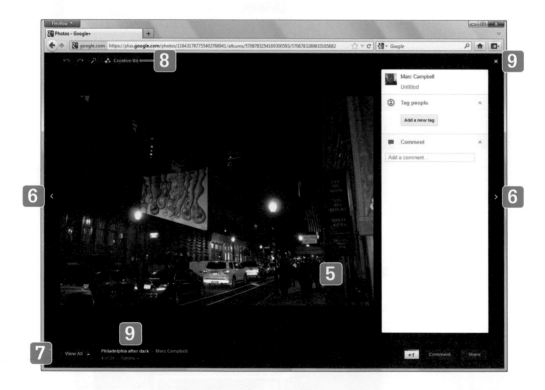

HOT TIP: Remember, you can go to your Photos page by clicking the Google+ Photos link in the upper right corner of the Picasa interface, as long as you're logged into Google+ from Picasa.

Resize the image in Google+

Resizing an image means to blow it up or shrink it down. This procedure is different from cropping in that you preserve the entire image. In other words, you don't trim anything away, you simply make the image larger or smaller.

1 From a Google+ album, open the photo that you want to resize and click the Creative Kit link.

> ⚠️ **ALERT:** Increasing the size of the image can magnify limitations in the quality of the original photo.

2 Under the Basic Edits tab, click Resize.

3 Tick the Use Percentages option.

4 Type a percentage value in either the width field on the left or the height field on the right. Anything greater than 100 makes the photo proportionately larger, while anything lower than 100 makes the photo proportionately smaller.

5 Click Apply.

6 Click Save, then click Save a new copy to save the photo back to the album.

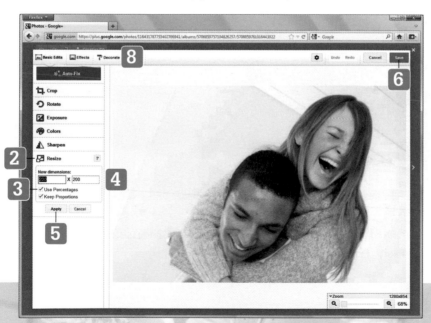

> 🔥 **HOT TIP:** To stretch or squeeze the image, untick the Keep Proportions option and enter unequal percentage values.

> ❓ **DID YOU KNOW?**
> The digital zoom of your camera resizes the image using a similar process and then crops the image to fit your chosen picture size.

Remove blemishes in Google+

Google+ provides a retouching tool specifically designed to fix skin imperfections. Use it whenever you need to gloss over pimples, spots, warts, moles, small tattoos, etc.

1 From a Google+ album, open the desired photo and click the Creative Kit link.

2 Switch to the Effects tab, look under the TouchUp group and click Blemish Fix.

3 Use the Zoom control so that you have a clear view of the blemish.

4 Set the size of the brush by dragging the Brush Size slider.

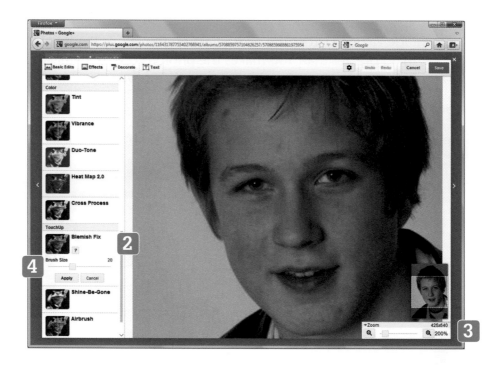

5 Position the brush over the blemish and click the mouse button. You may need to zap the blemish three or four times to get rid of it.

? DID YOU KNOW?

Glamour photography makes use of similar techniques, not just once in a while but all the time. That supermodel with skin too flawless to be true? It's too flawless to be true.

6 Click Apply.

7 Click Save, then click Save a new copy to save the photo back to the album.

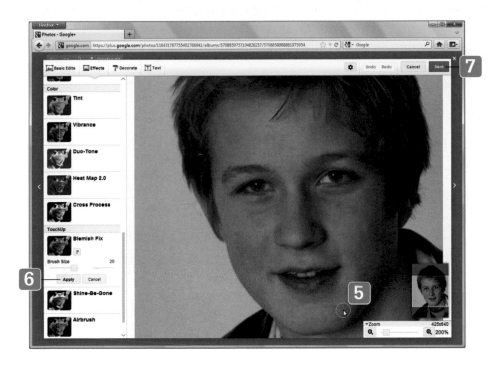

Reduce skin glare in Google+

Sometimes your source of good, strong light, be it the sun, a bright lamp or the flash of your camera, causes glare to appear on foreheads and cheeks. Lessen the prominence of glaring skin with the Shine-Be-Gone effect in Google+.

1 From a Google+ album, open the desired photo and click the Creative Kit link.

2 Switch to the Effects tab, look under the TouchUp group and click Shine-Be-Gone.

3 Drag the Brush Size slider to change the size of the brush.

4 Move the brush onto the glare patch.

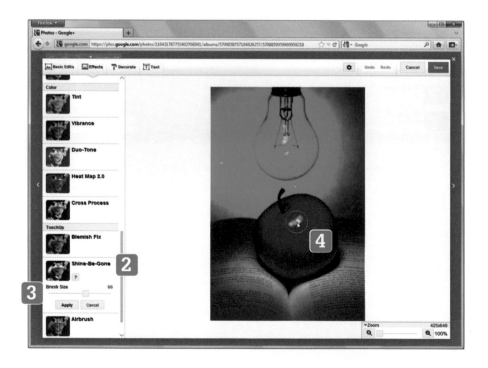

 HOT TIP: Try to make the brush just large enough to cover the glare patch.

SEE ALSO: For especially large or bright glares, consider adjusting the photo's exposure level instead. See Chapter 7 for more information.

5 Click the mouse button. You may need to apply the effect more than once.

6 Click Apply.

7 Click Save, then click Save a new copy to save the photo back to the album.

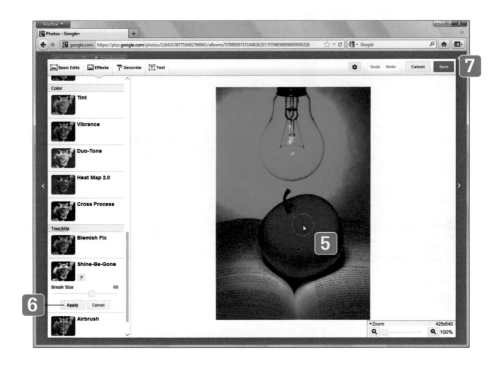

Even out complexion in Google+

Airbrushing is a technique in glamour photography for smoothing out texture and balancing tone. If you find that your freckles are out of control or the harsh light of your flash makes your pores look like craters, a few passes with the airbrush might improve your close-up.

1 From a Google+ album, open the desired photo and click the Creative Kit link.

2 Switch to the Effects tab, look under the TouchUp group and click Airbrush.

3 Adjust the size of the brush by dragging the Brush Size slider.

4 Move the brush onto your photo.

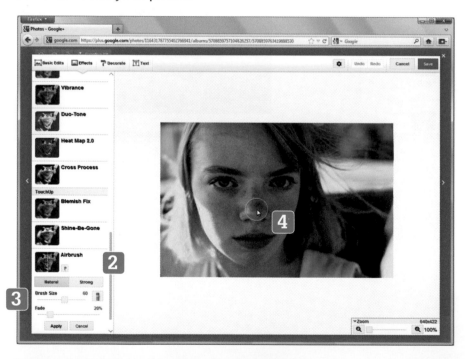

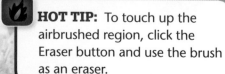

? DID YOU KNOW?

An airbrush is a device for spraying a fine mist of paint. Artists use airbrushes to blend colours and create extremely soft, wispy 'brushstrokes'.

HOT TIP: To touch up the airbrushed region, click the Eraser button and use the brush as an eraser.

5 Drag the mouse to apply the airbrush.

6 Click the Natural button for a more subtle effect, or click the Strong button for a more pronounced effect.

7 Drag the Fade slider to the left or right to decrease or increase the visibility of the effect.

8 Click Apply.

9 Click Save, then click Save a new copy to save the photo back to the album.

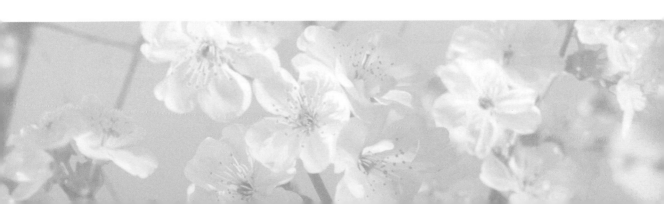

Add a suntan in Google+

Didn't get as much sun as you'd have liked during your mini-break on the continent? Doctor the photographic record with the Sunless Tan effect in Google+. It's not sticky or messy like liquid tan, and it comes with no risk of melanoma.

1 From a Google+ album, open the desired photo and click the Creative Kit link.

2 Switch to the Effects tab, look under the TouchUp group and click Sunless Tan.

3 Choose the colour of the tan by clicking any of the available colour swatches.

4 Increase or decrease the size of the mouse pointer by dragging the Brush Size slider.

5 Move the mouse pointer onto the photo.

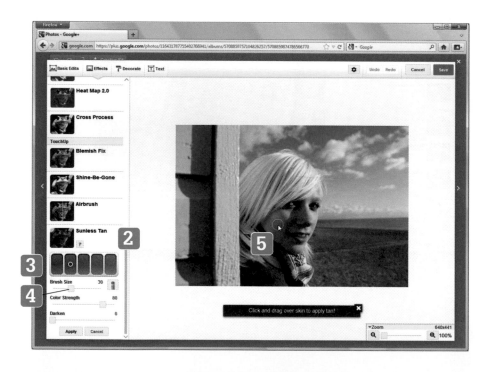

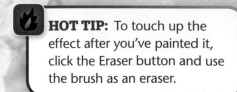 **HOT TIP:** To touch up the effect after you've painted it, click the Eraser button and use the brush as an eraser.

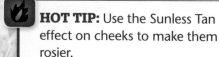 **HOT TIP:** Use the Sunless Tan effect on cheeks to make them rosier.

6 Drag the mouse to apply the effect.

7 Increase or decrease the intensity of the effect by dragging the Colour Strength slider.

8 Darken the colour of the tan by dragging the Darken slider to the right.

9 Click Apply.

10 Click Save, then click Save a new copy to save the photo back to the album.

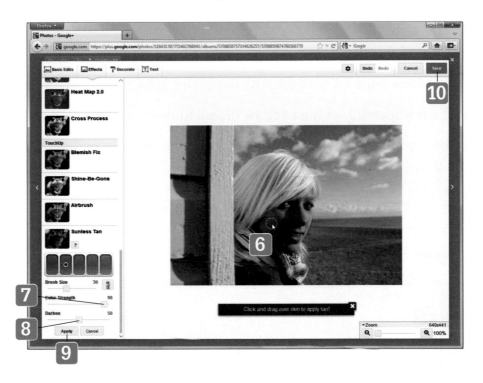

Apply face paint in Google+

Who among us hasn't worn our team colours? Yet so few of us have painted our faces and bodies with them. Thanks to digital photography and Google+, anyone can display an obsessive team spirit without sacrificing what is left of their dignity.

1 From a Google+ album, open the desired photo and click the Creative Kit link.

2 Switch to the Decorate tab and click Face Paint.

3 Choose the colour of the paint by clicking any of the available colour swatches.

4 Set the size of the brush by dragging the Brush Size slider.

5 Increase the transparency of the paint by dragging the Fade slider to the right.

6 Position the brush, hold down the mouse button and drag the mouse to apply the paint.

7 Click Apply.

8 Click Save, then click Save a new copy to save the photo back to the album.

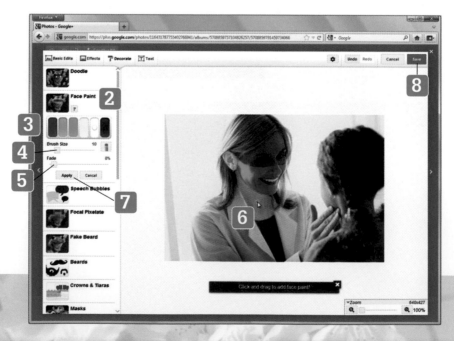

HOT TIP: To remove paint, click the Eraser button and use the brush as an eraser.

HOP TIP: To apply multiple colours of paint to the same image, click Apply before choosing a new colour swatch.

Draw on the image in Google+

Why should graffiti artists have all the fun? You can draw and colour on any photo when you edit it in Google+. Moustaches, devil's horns: the sky's the limit.

1 From a Google+ album, open the desired photo and click the Creative Kit link.

2 Switch to the Decorate tab and click Doodle.

3 Set the appearance of your doodle using the controls under this effect.

4 Position the brush on the image, then hold down the mouse button to draw or colour.

5 When you've finished, click Apply.

6 Click Save, then click Save a new copy to save the photo back to the album.

HOT TIP: If you can't see what you're doing, use the Zoom slider at the bottom of the screen to magnify the image.

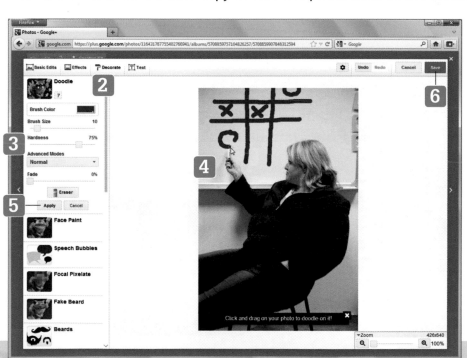

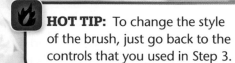

HOT TIP: To turn the brush into an eraser, click the Eraser button.

HOT TIP: To change the style of the brush, just go back to the controls that you used in Step 3.

Add clip art to the image in Google+

Google+ offers a variety of *stickers*, which work like pieces of clip art. You choose the sticker that you want to use, then you place it in your photo. You can change the size and even the colour of the sticker to suit your needs.

1 From a Google+ album, open the desired photo and click the Creative Kit link.

2 Switch to the Decorate tab.

3 Click any of the Decorate items that contain stickers, such as, Beards, Crowns & Tiaras and Masks.

4 Click a piece of clip art within this item to add to the image.

5 Position the clip art by dragging it.

6 Resize the clip art by dragging one of its corner handles.

7 Rotate the clip art by dragging its rotation handle.

8 Click Save, then click Save a new copy to save the photo back to the album.

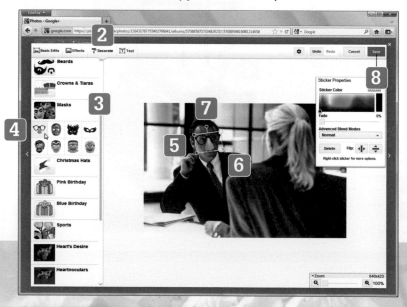

HOT TIP: To change the colour and style of the clip art, use the controls in the Sticker Properties panel.

Distort the image in Google+

Practical photographical jokesters, take note! The Gooify tool in Google+ is perfect for turning friends and family members into mutations, aberrations, abominations and monstrosities without any of the costs, ethical concerns or irreversible side effects of genetic engineering.

1 From a Google+ album, open the desired photo and click the Creative Kit link.

2 Switch to the Decorate tab and click Gooify.

3 Increase or decrease the amount of the effect by dragging the Strength slider to the right or left.

4 Position the brush on the image.

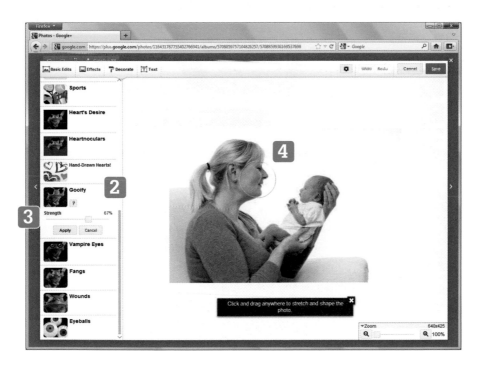

HOT TIP: You can drag the Strength slider to fine-tune the effect after you distort the photo (but before you click Apply).

? DID YOU KNOW?
If you make a mistake, click Cancel and start again.

5 Drag the part of the photo that you want to distort.

6 When you've finished, click Apply.

7 Click Save, then click Save a new copy to save the photo back to the album.

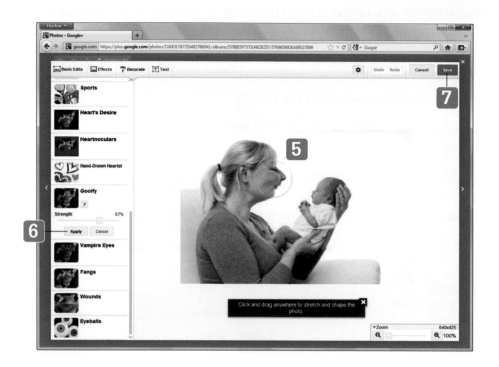

Pixelate faces in Google+

When you post photos online that anyone in the world can view, you may occasionally wish to protect the identities of some of the people in the shot. When simply cropping these people out of the photo isn't realistic because of the composition of the shot, you can *pixelate* their faces, which is to render their features as a pattern of boxes.

1 From a Google+ album, open the desired photo and click the Creative Kit link.

2 Switch to the Decorate tab and click Focal Pixelate.

3 Tick the Reverse effect option, if it is not already ticked.

4 Move the mouse pointer onto the photo and click to create the pixelated region.

5 Drag the Pixel Size slider to the left or right for smaller or larger pixels.

6 Drag the Focal Size slider to the left or right to decrease or increase the size of the pixelated region.

7 Drag the Edge Hardness slider to the left or right to soften or harden the blending between the pixelated region and the rest of the photo.

8 Drag the Fade slider to the right to mix in a portion of the original image.

9 Click Apply.

10 Click Save, then click Save a new copy to save the photo back to the album.

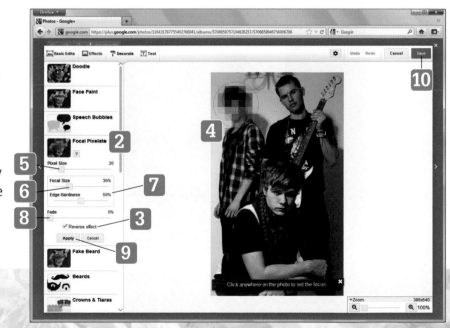

HOT TIP: Once you have created the pixelated region, you can drag it across the image to reposition it.

ALERT: If the pixels are too small, the person's identity may still be obvious when the photo appears as a thumbnail.

Download photos from Google+

Once you've edited a photo in Google+, you must download the photo if you want to keep a copy of the edited version on your computer. You may also need to download the photo if you plan to use it in another application or on a different social media site – the site may not be able to grab the photo from Google+, but it can certainly grab the photo from your hard disk.

1 From a Google+ album, open the photo that you wish to download.

2 Click the Options link and choose Download full size.

3 Download the image using your Web browser's download manager.

4 Locate the downloaded photo on your computer.

5 Cut or copy the photo from its download location and paste it in your Photos folder.

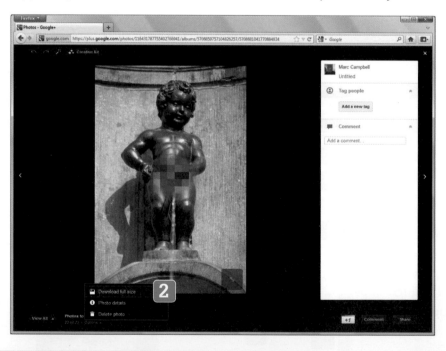

 HOT TIP: If you don't know where your browser downloaded the photo, try looking in your Downloads folder.

ALERT: If you paste the edited photo in the same folder as the original, be sure to use a different file name for the edited version. Otherwise, your computer will overwrite the original image.

10 Make prints (and more)

Introduction

Good old-fashioned prints aren't obsolete yet. You can choose to print your photos at home, or you can use a commercial service – Picasa handles both tasks with ease. But why stop there? Screensavers, desktop wallpaper, slideshows, movies – all this and more can be yours for free.

Print photos at home

If you own a printer, you can make high-quality prints of your photos at home from Picasa. Any printer with any kind of paper will suffice, but a printer especially designed for photos and loaded with the right stock of photo paper will give you the best results.

1 In Picasa's Library view, click a photo to print.

2 Click the Hold Selected Items button in the tray at the bottom left of the window.

3 Click the Print button.

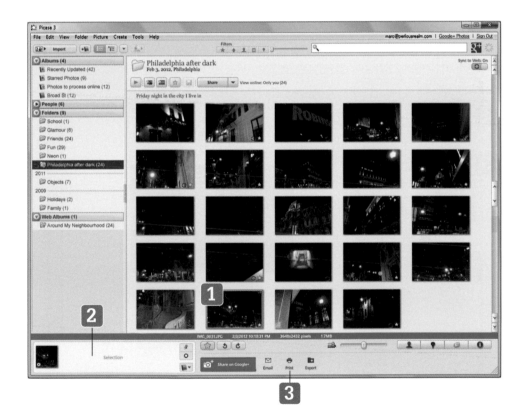

SEE ALSO: You can burn a CD or DVD of your photos for printing at a print shop – see 'Create a photo disc' later in this chapter.

HOT TIP: Continue adding photos by repeating Steps 1 and 2.

4 Under Print Layout, click the desired dimensions of the print.

5 Click the Shrink to Fit button to resize the image to fit the print. You see the entire image, but Picasa may add some space around it (much like a letterboxed video on TV).

ALERT: If you are printing more than one photo, they must all use the same print dimensions.

6 Click the Crop to Fit button to crop the image to fit the print. You won't get any space around the image, but Picasa may cut off part of the edges.

7 Set the other options for the photos and your printer as required.

8 Click the plus and minus buttons to increase or decrease the number of prints.

9 Click Print.

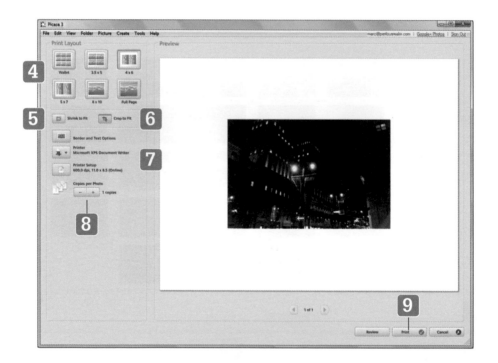

HOT TIP: For better control over how a photo is cropped, crop the photo to the desired dimensions before printing.

? DID YOU KNOW? If your photos would look bad under the chosen settings, a warning icon appears on the Review button.

Order prints online

If you don't own a photo printer, or if you prefer the look and feel of professionally produced prints, you can use Picasa to place a print order with whichever service you choose. However, it's very important that you crop your photos to the desired dimensions before you send the photos off for printing. Find the choice of print dimensions by visiting the service's website.

1 In Picasa's Library view, click a photo to print online.

2 Click the Hold Selected Items button in the tray at the bottom left of the window.

3 Choose File > Order Prints from the main menu.

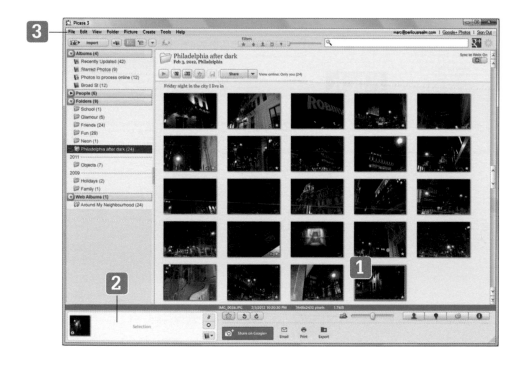

SEE ALSO: For details on cropping your photos, see Chapter 7.

HOT TIP: To select all the photos in an album or folder, simply click the album or folder.

4 From the Location drop-down menu, choose where you live.

5 From the list of providers that appears, choose your favourite. Picasa transfers you to this provider's website.

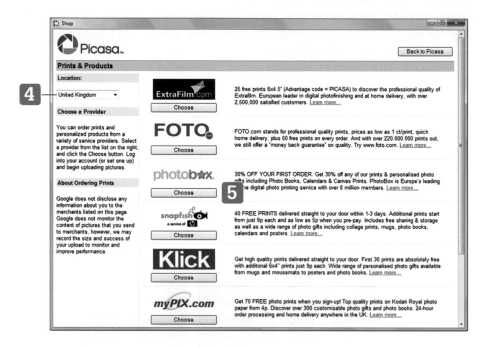

Print contact sheets

A *contact sheet* is a kind of proof that shows an entire series of images at a time. Professional film-based photographers often use contact sheets to determine which negatives to make into prints. Library view in Picasa serves much the same purpose for a digital photographer. Printed contact sheets make excellent photo references to include with your CD or DVD archives.

SEE ALSO: To learn how to make CD or DVD archives, see Chapter 5.

1 In the list of albums and folders on the left side of Picasa's Library view, click an album or folder.

2 Choose Folder > Print Contact Sheet from the main menu.

3 Set your printer and photo options as required.

4 Click Print.

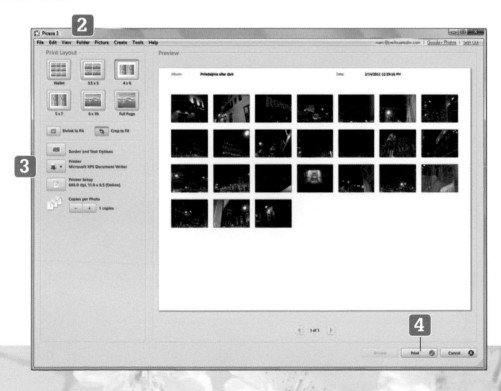

ALERT: Don't click any of the buttons under Print Layout unless you want to exit Contact Sheet mode.

HOT TIP: You don't need to use photo paper for contact sheets, ordinary printer paper is sufficient.

Create a poster

Picasa's poster project takes one of your photos and prints it across multiple sheets of paper. Just tape or glue the pieces together and your poster is wall-ready, as we say in the business.

1 In Picasa, open the photo that you want to print as a poster.

2 Under the Commonly Needed Fixes tab, click Crop.

3 From the drop-down menu, choose 4 × 6 or 8.5 × 11, depending on which size paper you print on.

4 Drag a rectangle over the photo to select the area to use as the poster.

5 Click Apply.

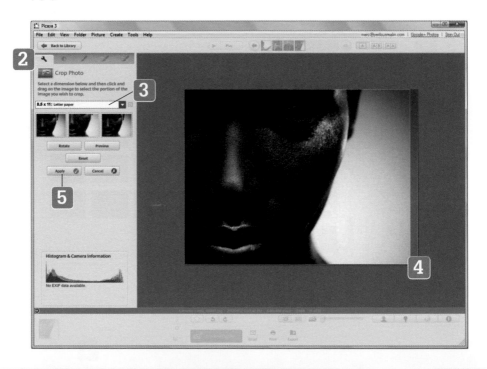

HOT TIP: You can move the selection rectangle after you've drawn it.

6 From the main menu, choose Create > Make a Poster.

7 Under Poster size, choose how large a poster to create. For example, choosing 200% creates a 2 × 2 grid, requiring four sheets of paper in total.

8 Under Paper size, choose the size of your paper.

9 Tick the Overlap tiles option if you want the edges of adjacent tiles to overlap slightly.

10 Click OK. Picasa creates a new image file for each tile of the poster. These image files appear in the same album or folder as the original image.

11 Go back to Library view in Picasa.

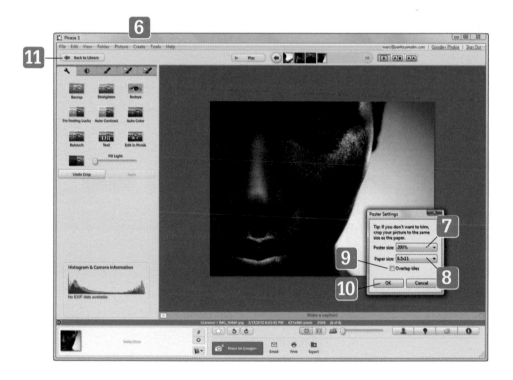

HOT TIP: There's no reason why you can't send the tile images to your preferred printing service if you would rather not print them at home.

12 Create a new album.

13 Move the tile images into it.

14 Print the new album on your printer.

15 Assemble the tiles to make your poster.

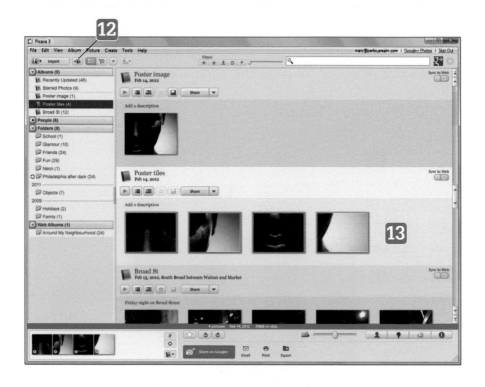

Export photos as image files

I mentioned in Chapter 7 that to work with the edited versions of your photos in software other than Picasa, you must either save or export the image files. Saving creates image files that are the same size and quality as the originals, but when you export your photos, you can change their size and the quality to suit your purposes.

1 In Picasa's Library view, click a photo to export.

2 Click the Hold Selected Items button in the tray at the bottom left of the window.

3 Click the Export button.

4 Click Browse to choose a location on your computer to save the exported photos, or simply use the default location that Picasa provides.

5 In the Name field, type a name for the folder that will contain your exported photos, or just use the default name.

6 Tick the Add numbers option to include sequential numbers in the file names of the exported photos. Doing so helps to keep the photos in order.

7 If you want to create smaller versions of the exported photos (for example, for sharing online), choose Resize to under Image size and drag the slider to set the desired width. Otherwise, choose the Use original size option.

8 Under Image quality, choose an option for determining how much of the original visual information is preserved in the exported photos.

9 To attach a notice to your exported images, tick the Add watermark option and type the notice in the field.

10 Click Export.

> **! ALERT:** Lower-quality images are easier to store and share, but they aren't usually much to look at.

> **🔥 HOT TIP:**
> Picasa adds the watermark to the exported photo's metadata.

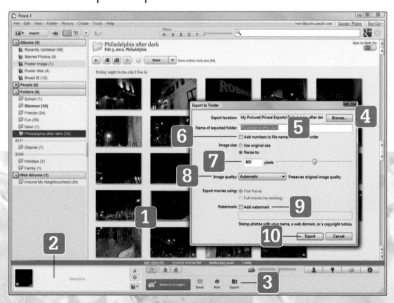

Email photos without Google+

If you're unconvinced about this whole Google+ business, or if you live and die by Facebook, you can use Picasa to share digital photos the semi-old-fashioned way: by sending them directly by email. Picasa keeps track of which photos you've sent out in the special Emailed album, which appears in Library view.

1 In Picasa's Library view, click a photo to email.

2 Click the Hold Selected Items button in the tray at the bottom left of the window.

3 Click the Email button.

4 Choose whether to use your computer's default email application or Google Gmail.

5 A new email message opens with your selected photos already attached. Compose your email and send it off.

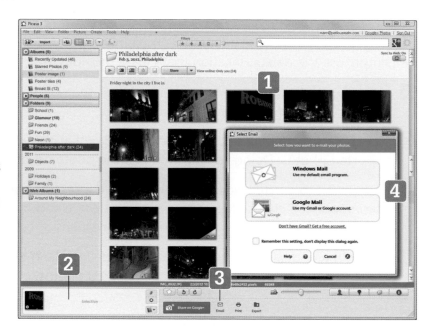

ALERT: Don't try to send too many photos in the same email. Your email service (or your recipient's) might get bogged down and your email might not get delivered.

Publish photos to your Blogger blog

I'm sure it's just a coincidence that Google Picasa links up with Google Blogger. But if you happen to blog on Blogger, your photo library is at your disposal. And if you don't yet have a Blogger blog, you may as well sign up for one. Picasa makes it easy.

1 In Picasa's Library view, click a photo to publish on your blog.

2 Click the Hold Selected Items button in the tray at the bottom left of the window.

3 Choose Create > Publish to Blogger from the main menu.

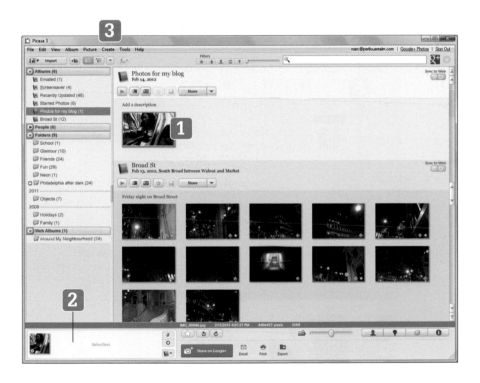

HOT TIP: To publish multiple photos in the same blog post, repeat Steps 1 and 2.

HOT TIP: After you sign in, if you don't yet blog on Blogger, click the Create a Blog link and follow the instructions onscreen.

4 If necessary, type the email address and password that you use to log in to your Google account and click Sign In.

5 Choose a Blogger blog from the Select a blog drop-down menu.

6 Under Choose a layout, pick the layout for your blog post.

7 Under Image size, choose how large you want the image files to be.

8 Click Continue.

9 Compose the blog post.

10 Click Publish Post to publish the post to your blog, or click Save As Draft to save your work for posting later.

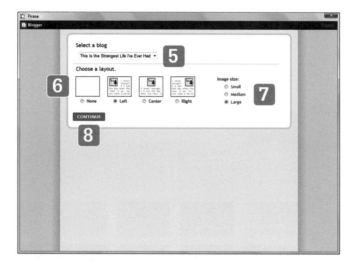

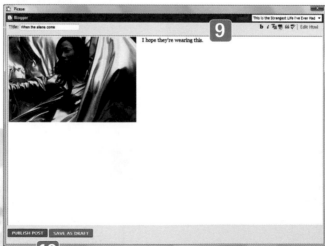

Create desktop wallpaper

You're only six short steps away from plastering your favourite photo across your computer's desktop view. For best results, avoid using lower-quality images, especially if you have a large monitor screen.

1 In Picasa, open the photo that you wish to place on the desktop.

2 Under the Commonly Needed Fixes tab, click Crop.

3 From the drop-down menu, choose 16:10 if you have a widescreen monitor or 4:3 if you have a standard-width monitor.

4 Drag a rectangle over the photo to select the area to use as the desktop wallpaper.

5 Click Apply.

6 From the main menu, choose Create > Set as Desktop.

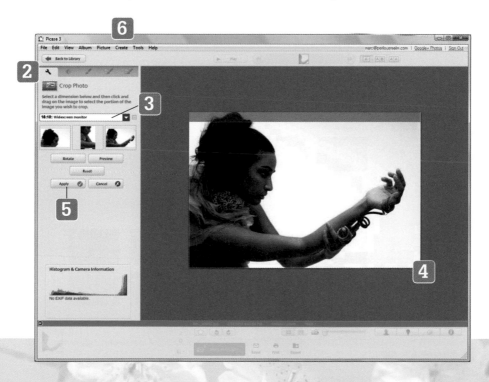

HOT TIP: Don't forget, you can move the selection rectangle after you've drawn it.

HOT TIP: Your wallpaper appears in Library view under the Projects list category.

Create a screensaver

Picasa enables you to specify any number of photos from your library as the screensaver for your computer. The screensaver transitions from photo to photo according to settings that you can configure at any time by editing the screensaver in your computer's operating system.

1 In Picasa's Library view, click a photo, album or folder to add to your screensaver.

2 Click the Hold Selected Items button in the tray at the bottom left of the window.

3 Choose Create > Add to Screensaver from the main menu.

4 Review your screensaver's settings in your computer's operating system.

5 You can add photos to your screensaver at any time by dragging photos in Library view to the special Screensaver album that Picasa creates.

6 To remove a photo from the screensaver, select its thumbnail in the Screensaver album and press Delete.

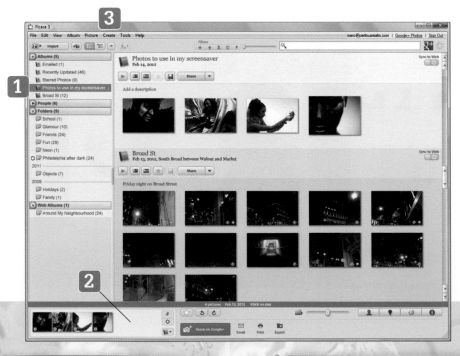

HOT TIP: To add multiple photos at the same time, repeat Steps 1 and 2.

ALERT: If your screensaver isn't displaying the right photos, check the screensaver's settings in your computer's operating system.

Create a slideshow

A *slideshow* in Picasa is a presentation of photos that runs in fullscreen mode on your computer's monitor. You can set the order of the photos and the method of transition, and you can even add background music.

1 In the column of albums and folders on the left side of Picasa's Library view, double-click the album or folder to use for the slideshow.

2 Review the properties of the album or folder and change them as required.

3 If you want to include music in the slideshow, tick the Music option and browse to the location of a music file.

4 Click OK.

5 Click the Play Fullscreen Slideshow button for this album or folder.

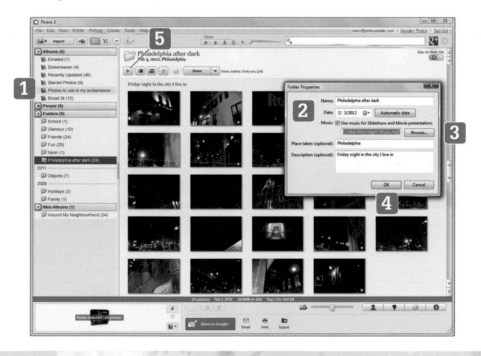

HOT TIP: Use voice-recording software to make your own narration track for the background audio of the slideshow.

HOT TIP: If you don't have a single album or folder with all the photos that you want to use, create a new album.

6 Move the mouse to reveal the control bar at the bottom of the screen.

7 Choose a transition method from the drop-down menu. This setting determines how Picasa switches from photo to photo.

8 To include the photo captions, tick the caption option.

9 Click the Play button to resume playback.

10 Click Exit or press ESC to return to Library view.

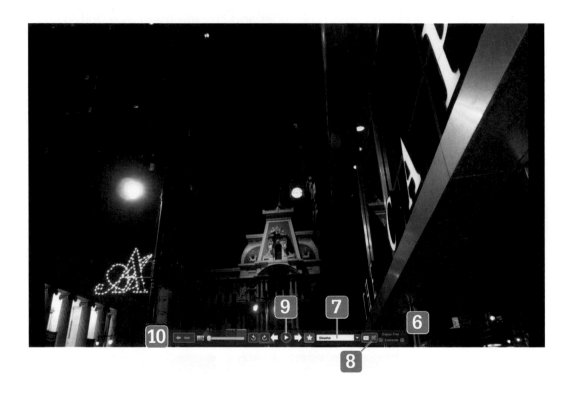

? DID YOU KNOW?
Picasa can play MP3 and WMA music files.

HOT TIP: Picasa automatically remembers your custom playback settings for the slideshow.

Create a movie from a slideshow

Your slideshow presentations play inside Picasa, but you can turn any slideshow into a multimedia movie file that plays in a variety of applications. You can also upload your movie from Picasa directly to YouTube for the viewing pleasure of the entire world.

1 In the column of albums and folders on the left side of Picasa's Library view, select the album or folder to use for the movie. For best results, choose an album or folder for which you've already created a slideshow.

2 Click the Create Movie Presentation button for this album or folder.

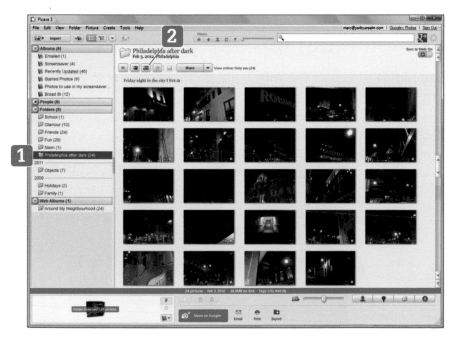

3 Under the Movie tab, click Load under Audio Track to specify the audio file to use if you haven't already done so for this album's slideshow.

 HOT TIP: Look under Create > Movie in the main menu to use different kinds of photo sets as the basis of your movie.

ALERT: Depending upon your audio option, you may not be able to adjust slide duration or overlap.

4 Under Options, choose how to reconcile the length of the slideshow with the length of the audio track.

5 Under Transition Style, choose how to switch between photos and adjust the slide duration and overlap as required.

6 Under Dimensions, choose the dimensions of the movie.

7 Tick the Show Captions option to include your photo captions.

8 Tick the Full frame photo crop option to crop your photos so that they fill the frame. Otherwise, Picasa may add space around your photos, depending on the movie dimensions.

9 Switch to the Slide tab and choose the format and layout of the text content.

10 Switch to the Clips tab and add or remove photos for use in the movie.

11 Preview the movie by clicking Play. To stop playback, click Pause.

12 Click Create Movie to export the movie file, or click YouTube to publish the movie directly to YouTube.

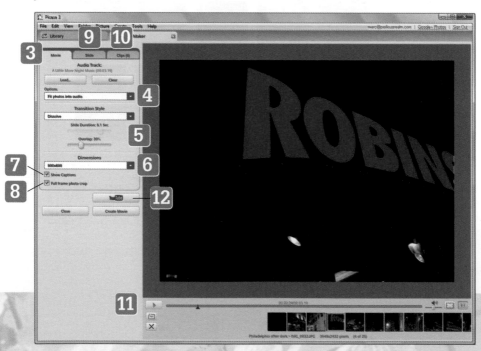

HOT TIP: Revise the order of the slides by dragging them around the timeline.

HOT TIP: Insert text slides between photo slides by clicking the Add a New Text Slide button near the playback controls.

Create a photo disc

A photo disc is a CD or DVD of your digital photos made especially for viewing rather than storage. If you have a large number of photos to share with family and friends, putting the photos on a disc is a smart choice. You can include your slideshows and a copy of the Picasa software installer on the disc.

1 Place a blank CD or DVD in your computer's disc tray.

2 From the list of albums and folders on the left side of Picasa's Library view, select the first album or folder to include on the disc.

3 Choose Create > Create a Gift CD from the main menu.

4 If you want to include other albums or folders on the disc, click Add More and tick the albums and folders to include.

5 To include slideshows with their respective folders or albums, tick the Include Slideshow option.

6 To change the size of the photos on the disc, choose an option from the Photo Size drop-down menu.

7 Type a name for the disc in the CD Name field.

8 To include a copy of Picasa software on the disc, tick the Include Picasa option.

9 Click the Burn Disc button.

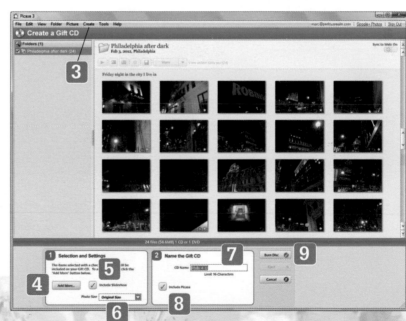

SEE ALSO: To create a disc for transferring photos to the chemist's for printing, try making an archive disc instead – see Chapter 5 for details.

HOT TIP: You don't need to include Picasa on the disc unless you want to share the software with your recipients.

Top 10 Digital Photography Problems Solved

Problem 1: My camera won't turn on

You seem to have a power problem. Your camera runs on either a specially designed battery pack or standard rechargeable or disposable batteries, and you need to recharge or replace the battery on a regular basis.

1 Check that you've placed the battery in the camera according to the instructions in your camera's manual.

2 If your camera uses a rechargeable battery pack or rechargeable batteries, take the battery out of the camera and recharge it.

3 You may need a new battery. Buy a replacement battery pack or some new batteries.

4 If your camera still doesn't turn on, check the manual for repair and warranty information.

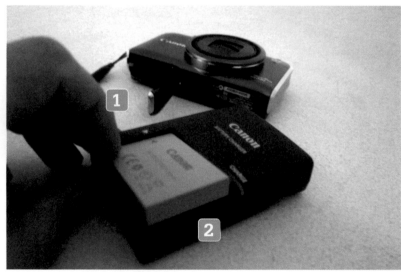

▶ **SEE ALSO:** For more information on recharging your camera's battery, see Chapter 1.

🔥 **HOT TIP:** If a friend or family member owns the same camera, ask to use this person's battery, just to verify that the battery is where your problem is.

⚠ **ALERT:** Only use the specific battery pack for your camera model. Don't use the battery from another model, even if the batteries look the same.

⚠ **ALERT:** Don't attempt to repair your camera on your own and don't use an unauthorised repair service.

Problem 2: My camera runs out of power too quickly

Your camera's battery will run out of power faster than you might like, even in the best circumstances. But if you notice that the camera is depleting the battery even more quickly than usual, you may be able to improve performance.

1 Avoid reviewing photos on the camera's LCD. The display drains power quickly.

2 In your camera's menus, find the power-saving or Auto Power Down settings and adjust them accordingly.

3 Turn off power-hungry features such as GPS and motion detection when you're not using them.

4 Don't rely on your camera to shoot full-motion video.

5 You may need to replace your camera's battery. Batteries lose their capacity over time, just through normal use.

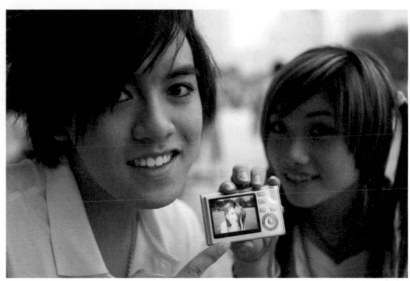

 HOT TIP: If your camera looks as though it has turned itself off, it may just be hibernating. Try pressing the shutter release halfway down to wake the camera up.

 HOT TIP: You might consider buying a spare battery for your camera bag. If you run out of power on a shoot, simply replace the batteries.

 HOT TIP: If you find that you need to capture video frequently, you might consider investing in a digital camcorder.

 ALERT: Overcharging your batteries makes them lose their capacity faster.

Problem 3: I run out of storage space on my camera too quickly

Your camera stores photos as digital image files. The characteristics of these files, including their quality and format, determine how many you can keep on your camera at any given time.

1 Lower the picture quality, which determines the amount of visual information in the photo. Lower quality gives you more storage space, but your photos might not look good at higher magnification levels.

2 Change the capture format from RAW or TIFF to JPEG. The JPEG format utilises compression, which means the image files take up less storage space at the expense of some fidelity.

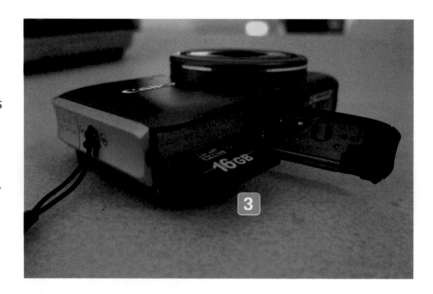

3 Use a higher-capacity memory card. The larger the memory card, the more photos you can store at a time.

> ▶ **SEE ALSO:** For more information on setting the picture quality, see Chapter 1.

> ▶ **SEE ALSO:** For more information on setting the capture format, see Chapter 1.

> ▶ **SEE ALSO:** For more information on using memory cards, see Chapter 1.

> 🔥 **HOT TIP:** You should consider carrying a spare memory card when you take your camera on holiday.

Problem 4: My photos are too dark when I shoot indoors

Adequate exposure is an ongoing challenge for indoor photography. What looks like normal, comfortable lighting to our eyes is often too dim for the camera. Try these easy suggestions for shedding some light on subjects.

1 Increase the amount of ambient light – open some curtains or turn on some lamps.

2 Review your camera's auto flash settings. The flash may be turned off, or you may need to set it to Always or Fill Flash for this particular shoot.

3 Review your camera's auto exposure or AE settings. If you are using Manual Exposure or M mode, you might try setting your camera for Program or P exposure mode.

4 Set your camera for an indoors Scene or SCN mode.

 SEE ALSO: For more information on Scene modes, see Chapter 2.

SEE ALSO: For more information on your camera's auto flash, see Chapter 2.

SEE ALSO: For information on auto exposure, see Chapter 2; for information on manual exposure, see Chapter 3.

Problem 5: My photos come out looking blurry or shaky

Blurry or shaky photos usually indicate problems with the focus or the stabilisation of the camera. Your camera comes with some auto-correction tools that should improve matters.

1 Review your camera's autofocus or AF settings. Feel free to turn off Manual Focus if you aren't comfortable adjusting the focus manually.

2 Review your camera's image stabilisation or IS settings. Always keep IS turned on whenever you hold the camera by hand.

3 Consider mounting your camera on a tripod.

 SEE ALSO: For more information on image stabilisation, see Chapter 2.

 HOT TIP: Feel free to brace yourself against a wall, a chair, the edge of a table – anything to steady yourself – when you're shooting by hand.

 SEE ALSO: For more information on autofocus, see Chapter 2; for manual focus, see Chapter 3.

Problem 6: The people in my photos have red eyes

This very common phenomenon occurs when the camera sees all the way through the pupils to the subject's retina. (It is not a reliable indicator of witchcraft!) If your camera can't correct it, your photo-editing software almost certainly can.

1 Turn on your camera's Red-eye Reduction mode, which uses a special lamp or a series of flashes to constrict the pupil.

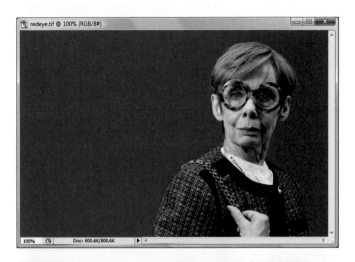

2 If your camera includes a Red-eye Correction function, you might consider turning it on.

3 Use photo-editing software such as Picasa to remove red-eye on your computer.

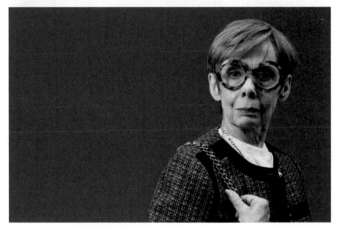

▶ **SEE ALSO:** For more information on red-eye reduction, see Chapter 2.

 ALERT: Red-eye correction in-camera isn't usually as effective as the similar function that you find in photo-editing software.

▶ **SEE ALSO:** For more information on removing red-eye in Picasa, see Chapter 7.

Problem 7: My photos look much larger onscreen than they do in print

This happens when the resolution of your digital photos is larger than the resolution of your monitor or TV screen. Screen resolution is typically 96 or 72 dpi, depending on whether you use a Windows or Macintosh computer. But print-quality photos often have a resolution of 300 dpi – three to four times greater than screen resolution. Since the screen can't make the dots any smaller, it makes the dimensions of the image appear larger than they actually are.

1 If you want to use these photos for prints, don't do anything. Just bear in mind that your photos aren't really this big.

2 If you want to display these photos on a website, export smaller versions of them using Picasa.

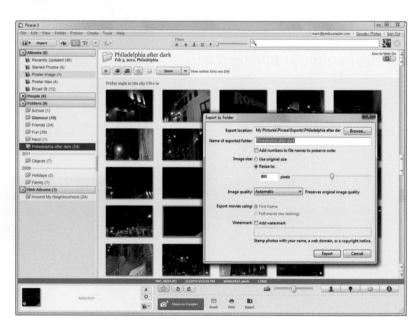

 SEE ALSO: For more information on exporting photos, see Chapter 10.

WHAT DOES THIS MEAN?

Resolution: This (in *dpi* or dots per inch) measures the amount of visual information in an image relative to its physical dimensions.

Problem 8: My photos look fine onscreen, but they look horrible in print

Resolution is the culprit. Your photos don't have enough visual information for print, which has higher resolution requirements than computer displays. The answer is to increase the amount of visual information in your photos.

1 Increase the picture quality. Higher quality equals more visual information, and more visual information means greater resolution at the desired physical dimensions.

2 Try making smaller prints. Decreasing the physical dimensions of the image increases the image's resolution (as long as the software doesn't *resample* the image, or toss out the extra resolution).

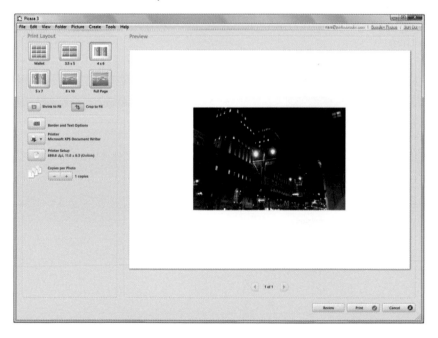

SEE ALSO: For more information on setting the picture quality, see Chapter 1.

ALERT: Once you've taken a photo, there's no way to put in the visual information that you left out by shooting at a lower picture quality, so always shoot at the highest quality that you can afford.

Problem 9: My photos take too long to upload to the Web or send by email

The resolution of your photos may be clogging the pipeline. The more visual information in a photo, the larger the image file becomes and the longer it takes to transfer this file electronically. And if your recipients don't intend to print your photos, all that extra resolution is wasted.

1 Decrease the picture quality, but be careful not to decrease it so much that your recipients won't be able to make good-looking prints if they wish.

2 Make smaller or lower-quality versions of the photos specifically for online sharing. In Picasa, you can do this by exporting your photos as image files.

3 If you upload your images to Google+, you can target the size of the photos for online sharing.

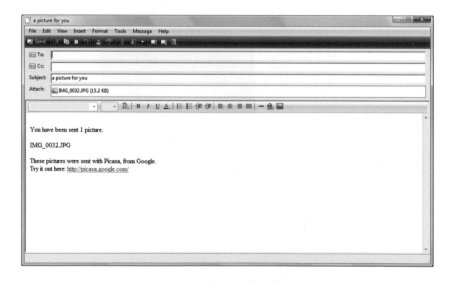

▶ **SEE ALSO:** For more information on setting the picture quality, see Chapter 1.

▶ **SEE ALSO:** For more information on exporting image files, see Chapter 10.

▶ **SEE ALSO:** For more information on uploading images to Google+, see Chapter 8.

Problem 10: When my photos come back from the chemist's, parts of the photo are missing

It's likely that the aspect ratio of your photos doesn't match the aspect ratio of the prints that you ordered. In the event of a mismatch, the chemist *crops* or trims your photos to fit. Digital photography makes it easy for you to crop your own photos to the desired dimensions before you send them off for printing.

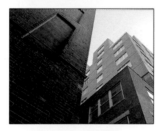

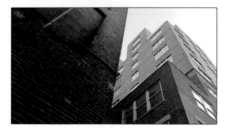

 SEE ALSO: For more information on cropping, see Chapter 7.

 SEE ALSO: For more information on resizing, see Chapter 9.

WHAT DOES THIS MEAN?
Aspect ratio: This is the proportion of an image's width to its height.

1. Crop the images so that they match the aspect ratio of the prints.

2. Resize the images so that they match the aspect ratio of the prints.

3. Change the *picture size* or the aspect ratio of the images that your camera captures to match the aspect ratio of the prints.

4. Order prints that match the aspect ratio of your photos.

ALERT: Depending on the difference of the aspect ratios and the way you resize the image, this technique can cause stretching or squeezing, create an effect like letterboxed videos, or reduce image quality.

HOT TIP: The same aspect ratio applies to any number of physical dimensions. For example, an aspect ratio of 3:2 matches 3 × 2, 4.5 × 3 and 6 × 4 prints, and so on.

SEE ALSO: For more information on setting the picture size, see Chapter 1.